Goals and Dreams

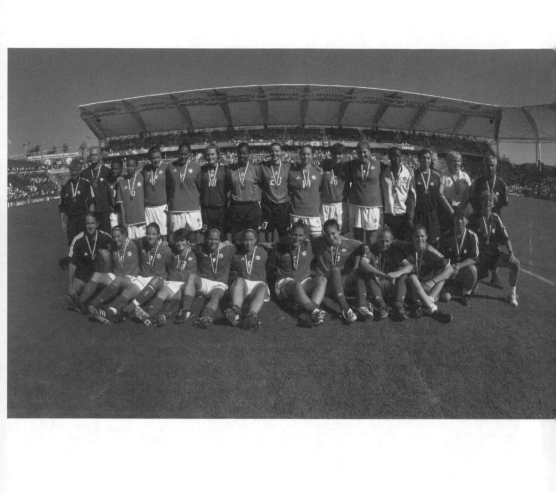

GOALS and DREAMS

A Celebration of Canadian Women's Soccer

Shel Brødsgaard and Bob Mackin

NIGHTWOOD EDITIONS

Nightwood Editions
R.R. #22, 3692 Beach Ave.
Roberts Creek, BC, Canada V0N 2W2
www.nightwoodeditions.com

Cover design by Peter Read. Cover photographs by Dale MacMillan.
Edited for the house by Julian Ross and Silas White.
Copy editing by Kathy Sinclair.
All photographs courtesy and copyright Dale MacMillan, except the photos on pages 22 to 34 and page 65 courtesy and copyright Michael Stahlschmidt.
Printed and bound in Canada.

Nightwood Editions acknowledges financial support from the Government of Canada through the Canada Council for the Arts and the Book Publishing Industry Development Program, and from the Province of British Columbia through the British Columbia Arts Council, for its publishing activities.

Library and Archives Canada Cataloguing in Publication

Brødsgaard, Shel
　　Goals and dreams : a celebration of Canadian women's soccer / Shel Brødsgaard, Bob Mackin.

ISBN 0-88971-205-0

　　1. Soccer for women—Canada. I. Mackin, Bob, 1970–
II. Title. III. Title: Goals and dreams.

GV944.5.B76 2005　　　796.334'082　　　C2004-903423-5

*This book is written in the memory of Mogens Brødsgaard,
my wonderful uncle who passed away far too early in life.
Luckily, he lived long enough to share his gift for appreciating
life and people.*

– Shel

*For my parents, Bob Sr. and Sherry, who let my love of soccer
blossom at an early age. And to all the players, coaches and
staff of Canada's national women's program: You deserve all
the praise you get and then some.*

– Bob

Contents

Acknowledgements

I would like to acknowledge and thank the many people involved in this story. First and foremost the Canadian Women's National Team Program – the entire group of players, staff, directors and officials who have been a part of this fabulous journey. Second, all of the fans, from coast to coast in Canada, who follow us through both good and bad. Third, all of my family and friends – your support and energy provide me with the strength to deal with the endless travel, hotel rooms, airplanes, buses, foreign meals, time changes, delays and stresses. Finally, thanks to the passionate soccer communities that continue to impact my life in so many positive ways – I hope you understand how much I appreciate your continued support and energy!

I would also like to thank Julian Ross for encouraging and enabling us to share this story.

–Shel Brødsgaard

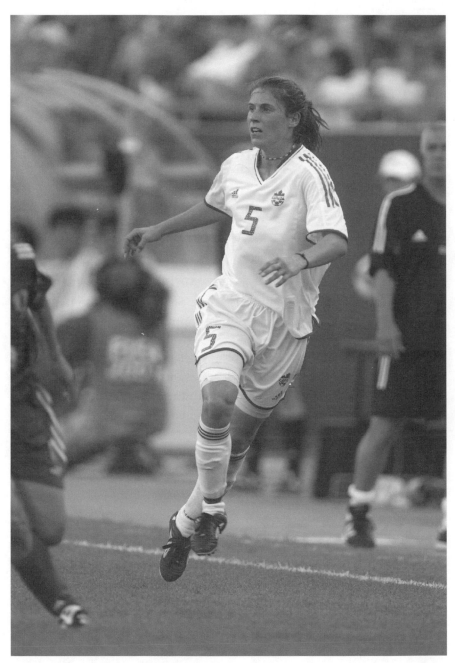

Andrea Neil, seen here in World Cup action against Japan, is a star veteran national team midfielder who played in her one hundredth international game for Canada against Costa Rica in March, 2004. She has played in the 1995, 1999 and 2003 World Cups, and is currently team captain and assistant coach for the Vancouver Whitecaps of the W-League.

Introduction

Andrea Neil, Canadian women's national team player since 1991

As a young athlete growing up, it was not uncommon for girls my age to look up to and admire the likes of Wayne Gretzky and Michael Jordan as our athletic role models. While these men are two of the greatest athletes to have ever played their respective sports, something was missing for me as a female athlete. I am a big believer in following your dreams; however, I also understood at a very young age that I was not going to compete in the NHL or the NBA. It wasn't until well into my national soccer team career that I realized there were many other girls from my generation in the same situation. We lacked female role models whom we could emulate.

Fast forward to a new generation of female soccer players. With the incredible victories of our Under-19 and World Cup women's teams in the past few years, youth players are now dreaming of one day donning the Canadian national team jersey and becoming the next Charmaine Hooper or Christine Sinclair. Young girls these days have very accessible and tangible examples of successful female players within their own sport.

The past struggles involving lack of funding and support that early female Canadian players endured have no doubt paved the path for the present-day athletes. With a gradual increase in funding, the Canadian women's team has been able to experience a huge rise in success, popularity, and consequently, development. We have become a distinguished world force in women's soccer. All of these improvements have in the end provided more opportunities for today's youth.

As a fourteen-year veteran of the team, I have seen the many faces of the game of soccer in Canada. I have also experienced the evolution of the women's international game and believe that it is continuing to change on a daily basis. As this evolution has unfolded, female players are being exposed to a higher level of soccer at a younger age, resulting in more sophisticated tactical and technical abilities. Couple this with the fact that today's players are, on average, bigger, faster and more powerful than even a few short years ago, and there is definitely a new breed of soccer player that is arriving and impacting the game.

I have had the time of my life during the tail end of my soccer career, being able to experience and be part of the new incarnation of the Canadian women's soccer team. In all of the changes that have taken place, the most important result is not specifically what's been done on the field, but the fact that because of what we've achieved, the players on our present team have become recognizable role models for our youth. The extent to which all of this will impact women's soccer in Canada is immeasurable. In knowing how far the program has come and to have a glimpse of where it is heading, I truly believe that there is no better time to be a female soccer player in Canada.

One day soon, it will be my absolute pleasure to sit back and watch the youth of today continue to raise the bar while competing for our country in this ever-evolving sport. *Goals and Dreams: A Celebration of Canadian Women's Soccer* will hopefully help to inspire countless determined young girls on their journey to become the future faces of Canadian women's soccer.

A Brief History of Canadian Women's Soccer

Bob Mackin

Canada's national women's soccer teams once struggled for recognition and results, always in the shadow of the better-funded men's teams. When the program began in 1986, practices and games were few and far between. Players even paid to play for their country by purchasing their own boots and airfare to international matches.

In the 2003 Women's World Cup, Canada won three games and finished fourth. This result signified a long journey in a short period of time – especially when you consider that Canada didn't qualify for the first Women's World Cup in China in 1991 and was knocked out of the first round of Sweden 1995 and US 1999 with a tie and two losses both times.

Today's national team trains regularly and routinely travels overseas for competition. The success of the game south of the border has spilled over into Canada, where girls are getting the same chance to play, travel and receive top-level coaching as boys. Not only do the dedicated, passionate female players have the privilege to play for a world championship, but they also have opportunities for scholarships, professional contracts and commercial endorsements.

When Geri Donnelly was picked to play for Canada's fledgling women's team in 1986, players could only dream they'd someday have the same opportunities as their male counterparts. Back then, it was satisfying just to wear the maple leaf and play at the highest level of women's soccer.

Donnelly played seventy-two times for Canada during her thir-

teen-year career as a midfielder. It all began July 9, 1986, when she scored Canada's first two international goals during a game against the United States in a suburban Minneapolis park. She was among a Canadian women's all-star team assembled after a Winnipeg tournament and sent south on a twenty-hour bus ride to meet the Americans. One of her teammates was Charmaine Hooper, who seventeen years later scored the most famous goal in Canadian women's soccer history against China at the 2003 Women's World Cup quarterfinal.

"We didn't even know there was a national team," says Donnelly, who also played basketball and studied at Simon Fraser University near Vancouver. "We were told that if there was going to be a national women's program, we had to be successful. We had three days training together, which was intense training. We were quite scared and didn't know what to expect."

The women's match with the US was but a rumour north of the border where soccer fans and media were focused on Canada's men's team that had returned from its only appearance at a World Cup – without even scoring a goal.

The women players had to train individually, buy their own boots – up to four pairs a year – and even pay airfare to tournaments. The Port Moody Soccer Club, Rotary Club and local Safeway grocery store raised $1500 to send Donnelly on a 1987 national team tour of Taiwan.

"We didn't really have a World Cup to look forward to at that time, we just wanted to play at the highest level we could. We struggled without training. Mostly we practised by ourselves, often in the pouring rain and sometimes even in the middle of the night. That's what we did, that was our life."

Donnelly retired after captaining Canada in the 1999 Women's World Cup, paving the way for Hooper and Andrea Neil to lead the team into a new era in which Canada would compete with any country.

The world's first-known organized women's team was started and flourished in England, despite a conservative, male-only soccer climate. During World War I, a factory in Preston in the north of England started a soccer team called the Dick, Kerr Football Club which lasted almost half a century. Wartime fundraisers at the home fields of Liverpool and Manchester United drew sellout crowds but raised the ire of the chauvinistic English Football Association. In 1921, the FA banned Dick, Kerr

from England's top stadiums because "football is quite unsuitable for females and ought not to be encouraged."

The team continued to play on smaller fields and even sailed across the Atlantic for opposition in 1922. There was no welcome mat in Canada: the Dominion Football Association echoed the English FA stance and wouldn't let the women play any local teams. Dick, Kerr looked south to the United States, but couldn't find any women to challenge. The team ended up winning three times and tying three times on an eight-game tour against men's teams.

During the 1920s, women's soccer games were documented in Hamilton, Ontario; Connecticut; New York; California; and even in Alberta's Crowsnest Pass, where teams formed on marital status: married women versus single women. Splitting teams along those lines wasn't unusual, says Ann Hall, author of *The Girl and the Game: A History of Women's Sport in Canada*: "They were novelty teams more than anything. There was no league."

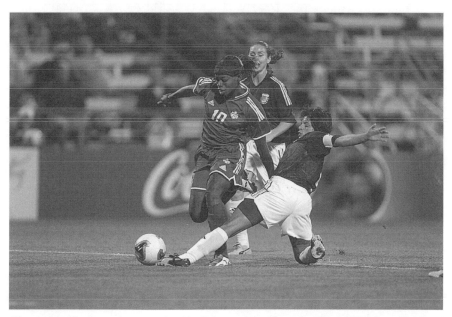

Charmaine Hooper, who was raised in Ottawa, was selected to the 2003 Women's World Cup all-star team. Hooper started her legendary international career in 1986 and has played professionally in Norway, Italy, Japan and the US. She holds Canadian records for international goals scored and games played, and was named MVP of the World All-Star Game in 1999.

Hall, a former professor of physical education at the University of Alberta, says two forces stimulated growth in women's soccer on opposite sides of the border in the 1970s. In the US, the 1972 federal Title IX legislation required funding equity for male and female athletes. In Canada, sons and daughters of cost-conscious baby boomers were turning to soccer in droves as an alternative to ice hockey.

Initially, girls had to play on boys' teams until "soccer took a very intelligent approach and they clearly and carefully established leagues for girls," she says.

In 1973, there were only three girls soccer clubs across British Columbia. By 1980, there were 317 teams playing under the BC Girls Soccer Association. In 2004, there were more than 347,000 women and girls playing nationally on registered teams – 42 percent of Canada's 825,000 players. In Ontario alone, there were 150,000 women and girls playing soccer. For every female in Canada playing hockey – the official national winter sport – there are five others playing soccer.

Like the Americans' 1999 Women's World Cup victory at home in front of 90,000 fans at Pasadena's Rose Bowl, the 2002 FIFA Under-19 Women's World Championship final in Edmonton was a landmark event in Canadian soccer.

"I was just astounded when I walked into Commonwealth Stadium in 2002 for the women's U-19 final," Hall says. "I never believed that I would see 47,000 people screaming at a bunch of teenagers playing girls soccer."

Without the success of that tournament – which introduced Canadians to Christine Sinclair, Kara Lang and Erin McLeod – perhaps Canada would never have placed fourth at the 2003 Women's World Cup. It demonstrated what proper funding, expert coaching, technical and tactical direction and a positive attitude can mean for a soccer team with goals and dreams.

Profile

Even Pellerud

Bob Mackin

Even Pellerud, head coach of Canada's World Cup Team, celebrates a win over Japan at the 2003 Women's World Cup. Pellerud, who coached Norway to victory in the 1995 Women's World Cup, has led Canada into the top ranks of women's soccer.

Canadian Women's National Team coach Even Pellerud is a self-described soccer maniac.

"I've loved soccer since I was born," says Pellerud, who is from Norway. "Day in, day out, snow, ice, rain. Summer, winter, spring. It was just year-round soccer and school."

Being in an isolated environment in a big country with a small population was perhaps the biggest obstacle Pellerud faced while growing up.

"Commuting in old cars, in winter storms in minus 20 degrees just to go to practice, 150 clicks away, back and forth. I've done that, all winter long in snow and ice and terrible gravel conditions. I think it's good

to have that background, because it makes you realize you cannot go to the top if you do not have some tough days."

When he was thirteen, he got a tryout with a senior team.

"They were my heroes. For me it was a big thing and it was more than an inspirational soccer environment. It was about sports and physical activity, summer sport, winter sport. That was helpful."

Pellerud played professionally for thirteen years with four Norwegian first division teams. He got his first coaching job at age thirty-two for Kongsvinger, and had to leave behind the fun part of soccer with "jokes in the locker room and being part of the group."

Coaching is a lonely life that keeps him away from his family for long periods of time. But it gives him a chance to form a second family.

"As a head coach you are the only one who is accountable, that is something you have to live with. But it helps to be able to build a staff around you, and I did that in Norway, built the staff myself, and am able to do the same (in Canada) with this team. It's quite a relief for me to have the staff I have here, the best staff I've ever had, very supportive and very hard-working."

Pellerud's mentor is Edgil Olsson, the former Norwegian Men's National Team coach. Olsson was Pellerud's teacher at the Norwegian University of Sport and Physical Education in Oslo where he graduated in 1979.

"He is the mastermind behind a lot of things I do. I believe in solid defence based on science and his research, and in that way he's been like a prophet."

Under Pellerud, Norway won the Women's World Cup in 1995, by upsetting the defending champion American team. His team also won a bronze at the 1996 Olympics in Atlanta. Three years later, a new challenge awaited as Pellerud decided to move to Canada and take over the under-performing Women's National Team. The team had been eliminated in the first round of the 1999 Women's World Cup and some veterans were contemplating retirement from the game.

"When I came here and accepted the position I didn't really know what I came to. Canada sounded nice and it was good timing for us as a family."

Pellerud promised his new employer, the Canadian Soccer Association, significant improvement and better results. He identified up-

and-coming youth players and convinced the skeptical veterans to give his leadership a chance.

"Good talent is coming up from the youth ranks and youth development programs, and strong veterans like Charmaine (Hooper) and Andrea (Neil) are there to be the backbone of the team. This mix is slowly but surely turning into a great team. Of course, the ambitions grew and the ambitions are still growing."

In exchange for hard work and loyalty to his vision, Pellerud promises his players freedom, including having fun at practice. When it's game time, however, it's "pure business."

As he paces the sidelines during a game, one can sense that he'd love to play again. His body may be off the field, but his spirit is in the game with his players.

Close to the end of practice, Pellerud often laces up his boots and joins his players on the field. He isn't as fast as he once was, but he still has some of the skills.

"I think a good coach should be active, meaning that you give good directions, clearly and loudly, so that you can change the game. I think a good coach can do that. Of course, some do that in a bad way and some do that in a good way – I recommend in the good way. An active coach on the sidelines is something that the players like to see, because they see passion and support and involvement."

Coaches often have to criticize their players, but Pellerud believes in offering constructive criticism, offering ways for improvement. A clear game plan with clear direction is key. A coach should stand up, give instructions, sit down and let the players play.

Pellerud constantly stresses the tactical side of the game to his players – ideas on the field that create plays and opportunities to score. They also offer methods of defending against an opponent's attack. Perfection can only be reached through practice, so the team practises tactics repeatedly. Drills are important, and so are scrimmages with one-touch, two-touch rules. It's ultimately the coach's responsibility to plan a training session that brings a team together to develop those individual skills.

"All these things in the game environment will help both development of skills and also the understanding of the tactics. They also have to practise skills outside the scrimmages – in between games, at home,

in school, in the backyard, everywhere they have the chance. Skills have to be practised again and again to be refined, to be precise; a combination of scrimmages and homework has to be done."

A coach can have the attention and trust of his players and formulate an effective training plan, but he must also be able to make tough and brave decisions when it comes to game time.

"You have to be strong enough and confident in your abilities, because if you fail, people will just stomp on you and say how stupid you are."

Pellerud had to make some of the toughest decisions of his coaching career when Canada was about to depart for the 2003 Women's World Cup. The team had been hit with several injuries during the summerlong series of friendly matches against international competition. Pellerud promoted players from the Under-19 and Pan-American Games teams. Some had never played a game with the senior national team. Pellerud then converted captain Charmaine Hooper from a striker to a defender, and after the tournament began, also switched goalkeepers. But he didn't choose the anticipated second choice of Erin McLeod. He gambled and went with Taryn Swiatek; however, McLeod still had a role to play.

"That is very important for a winning team, that you have players who can create an atmosphere where they sacrifice and still maintain their passion and motivation and support. Players like Erin McLeod were very impressive. [The starting goalkeeper] could've been her; it was very close."

Canada came a goal short of going to the final in a 2–1 semifinal loss to Sweden, just days after shocking defending silver medallist China with a 1–0 win in the quarterfinal.

Pellerud knew the team was ready to get to the quarterfinal round, but the semifinals?

"I think we overachieved with the team we had. You never know what will happen because that's just speculation. You can dream about that, but I think at the same time, the team is not quite ready to go to the top. Even with no injuries we have a very young team and are not yet sophisticated enough to play the game at the highest levels in the World Cup for six games in a row. We are getting there, they are close. There is reason to be optimistic on behalf of the future."

Compared to his Norway team that became world champions, where is speedy, skillful Canada?

"You see a lot of similarities with the players and their personalities, with good veterans leading the team. In Norway they were a little more tactically sophisticated, but this team is more talented. The potential here is even higher."

The 2002 FIFA Under-19 Women's World Championships

Shel Brødsgaard

The preparation for Canada's U-19 Team competing in the 2002 FIFA tournament started two years before the event, under the guidance and influence of Even Pellerud. One of the world's most renowned soccer coaches for women, Pellerud was hired by the Canadian Soccer Association in 2000. His first initiative was to install a staff for the entire women's program. Ian Bridge became the World Cup assistant coach and U-19 head coach and Lewis Paige was made assistant coach for the U-19 team. I was lucky enough to be named the goalkeeper coach of both teams.

Other team staff were added as well, creating a national women's program with teams at the U-17, U-19, U-21 and World Cup levels. As each of the youth teams practised and competed, they became important sources from which to scout up-and-coming players. As a result, a number of younger players were identified and moved up to play for the senior team. It was a combination of these senior team experiences, together with the amount of time spent in the new program that set the stage for success in Edmonton.

The benefactors of these senior team experiences were players such as Kara Lang, Brittany Timko, Erin McLeod, Candace Chapman and Christine Sinclair, who would all quickly go on to make an impact with the senior team.

Going into a world championship with a player such as Christine Sinclair on your team raises your level of confidence and the expectations for success. When she receives the ball and manages to break away

from the defender, with only the goalkeeper to beat, you know that she will score. This is a tremendous confidence builder for our team, and a constant worry for the opposition.

But never in our wildest dreams could we have predicted the success, both on and off the field, created by this team's remarkable run to the championship final game.

The inaugural FIFA U-19 Women's World Championships was hosted by Canada in the summer of 2002, bringing together the top twelve women's Under-19 teams from around the world. Before this competition, the European Championships had been the only organized tournament for this age group and as a result, the majority of the teams in the tournament were competing for the first time internationally. The tournament consisted of twenty-six games in three host cities: Victoria, Vancouver and Edmonton.

> **Group A:** Canada, Denmark, Nigeria, Japan
> **Group B:** Brazil, Germany, France, Mexico
> **Group C:** USA, Australia, England, Taiwan

Canadian fans showed up in unprecedented numbers for the 2002 Women's World Championships held at Edmonton's Commonwealth Stadium.

The tournament was a huge success with record crowds of more than 300,000. Commonwealth Stadium in Edmonton played host to twelve matches. The final, between Canada and the US, was played in front of almost 50,000 fans, and watched by a domestic television audience estimated at more than 900,000.

In May of 2002, Even Pellerud calmly predicted that Canada and the United States would meet in the final game of the upcoming FIFA Under-19 Women's World Championships. At the time, it seemed impossible to consider. Canada had never played at such a high level before in this age group, while the European teams had been competing in annual championships since 1998.

Even though they had long-established soccer traditions, European teams couldn't believe the interest that Canadians were showing for this tournament. Several months before the tournament I had expressed concerns about the number of fans who would attend the games, but advance ticket sales at Edmonton's Commonwealth Stadium were already approaching 30,000. Several months later, history was made for women's soccer, not only in Canada but, in fact, the world.

The spillover effect of the country's interest is still seen today with the expansion of the W-League, a North American semi-professional soccer league for women to Vancouver, London, Toronto, Ottawa and Sudbury. Each team provides current and future stars a chance to compete and benefit from a competitive soccer environment on a day-to-day basis. This daily commitment helps players to recognize and accept the challenges required to become elite international performers.

The team was in Edmonton several days before the start of the tournament, making our final practice preparations and staying in dorms at the University of Alberta. It was here that goalkeeper Erin McLeod and I trained in the mat room, better known as the Wrestling Hall – an area we visited many times to prepare physically and mentally for the competition. The mats provided a surface that allowed McLeod to repeatedly practise diving and ball-handling exercises with a lot less impact on her body than on natural grass.

I recall the day we moved away from the dorms to our tournament hotel, as we had chosen to stay away from the other teams during the actual competition. One of the first memories came when Amy

Christine Sinclair had a phenomenal tournament at the U-19 Women's World Championships, scoring ten goals in six games. Sinclair won trophies for most valuable player and top goal-scorer, and was selected to the FIFA All-Star Team.

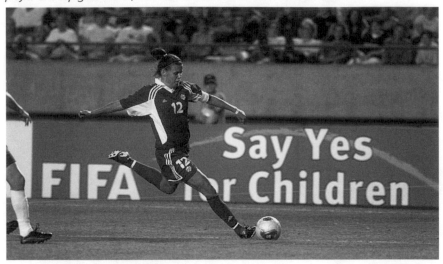

Vermeulen, a midfielder from Saskatchewan, strolled past Ian Bridge and me on her way to the hot tub in her bathrobe for a soak and some well-deserved relaxation. That's when Ian told me about his playing experience at the World Youth Championships, where he saw the great Argentine striker Diego Maradona strutting down a hallway in the same manner – relaxed, calm and confident. Little did we know that within the next two and a half weeks virtually unknown soccer players like Amy and her teammates would captivate the nation.

The key in any championship is to start with a positive team performance, in order to build confidence, and to importantly take early points in the group stage of the tournament. Our first tournament game was against Denmark, whom Even and I had scouted earlier in the year. The Danes were a technically good team that played a short passing game, but we felt they lacked the fitness and physical strength to compete with Canada.

Denmark, however, took the lead and tested our team early, making us work extremely hard to come back for a 3–2 victory. Christine Sinclair, Kara Lang and Michelle Rowe scored the goals. It was a massive boost of confidence for the players, and started the building of momentum for fan support, as well.

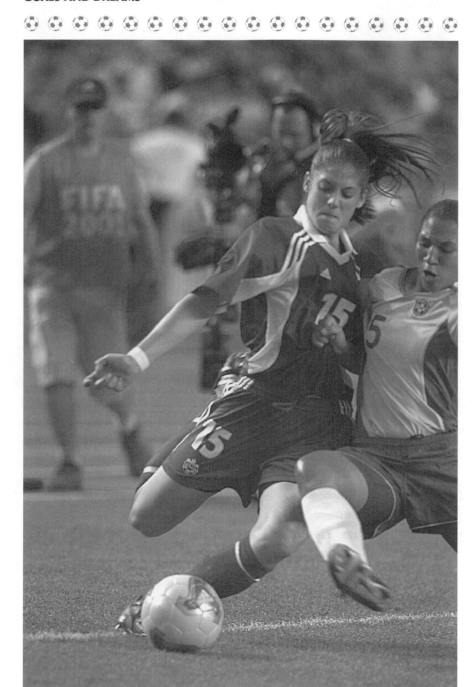

Kara Lang, the youngest player to ever score an international goal for Canada, emerged as a star player during the Under-19 tournament in Edmonton. Lang combined physical strength with skill and determination to score many important goals.

Erin McLeod created fantastically different hairstyles for each match, sometimes dying her hair in the red and white Canadian colours, and styling it into unusual shapes and patterns.

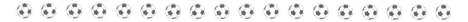

Each time we left the hotel for a walk, people on the street recognized the players and called out encouragement. When we turned on the television there were local and national stories broadcast about the team. Walking past newspaper boxes, we saw front-page action photos of the individuals slowly emerging as stars. Whether they were ready for it or not, the amount of attention brought to the team through the papers, television and internet was outstanding.

A few months before the tournament, the Japanese head coach scouted our team in Toronto. When he saw a few of the players – their size and physical strength – he turned to coach Bridge and stated, "Holy cow!"

The second game was against Japan, a technical team that lacked physical presence. The Canadian team relied on using more muscle. During the game it became clear how different the two teams' mentalities really were. The Japanese played a patient style of soccer, with many passes in the build-up toward the opponent's goal, but seemed to lack direction in the final third, or goal-scoring, area. The Canadian playing style is very direct – fast, forward and aggressive – which resulted in a convincing 4–0 win. Kara Lang and Christine Sinclair each scored two goals, with Erin McLeod earning the shutout.

In our third group stage match, against Nigeria, we played a solid team game, with McLeod earning her second consecutive shutout. Christine Sinclair scored in her third straight game, collecting both goals in a 2–0 win.

Again, the Edmonton crowds were strongly supportive, with a combined total of close to 60,000 fans watching our first three games. It was invigorating for us to hear their cheers and see the Canadian colours and flags. Many had painted faces and some even sported McLeod-replica hairstyles.

We met England in the quarterfinal game. Always known and respected for their historical involvement with the game on the men's side, England's women's program was in the initial stages of development. There is, in fact, a cultural difference between North America and Europe; in many European countries where men's soccer is the totally dominant sport, women have definitely not received equal encouragement to play.

With 24,000 fans cheering us on, we played an excellent game in earning an easy 6–2 victory. Katie Thorlakson scored her first goal of

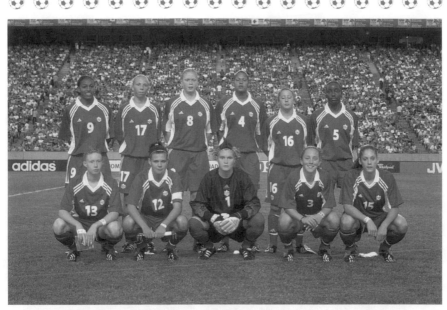

Team photo prior to the Brazil game. Front row: Melanie Booth (13), Christine Sinclair (12), Erin McLeod (1), Carmelina Moscato (3), Kara Lang (15). Back row: Candace Chapman (9), Brittany Timko (17), Clare Rustad (8), Sasha Andrews (4), Katie Thorlakson (16), Robin Gayle (5).

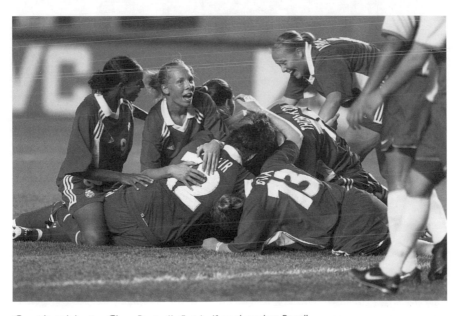

Canada celebrates Clare Rustad's first half goal against Brazil.

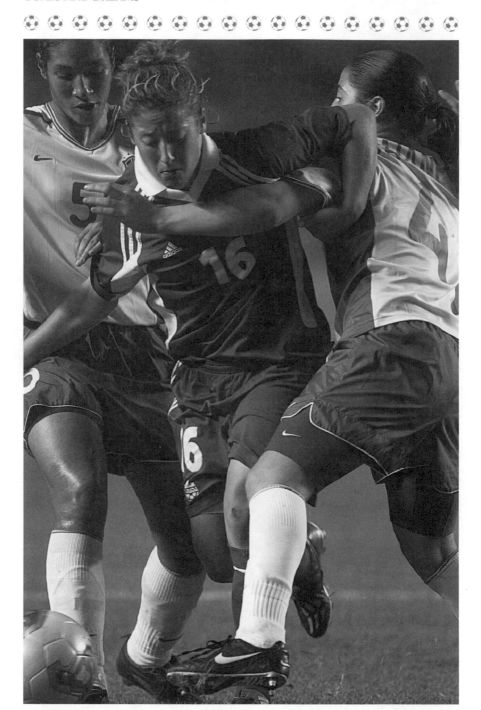

Katie Thorlakson, a forward who started playing soccer at age four in Langley, BC, tries to power her way through two players in the physical, tight-checking game against Brazil.

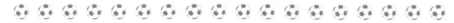

the tournament, while Christine Sinclair had an amazing match, piling five goals onto her tournament-leading total of ten goals.

On to the semi-finals, where our team faced both the the mental challenges accompanying the tournament and the increasing intensity of the games. Carmelina Moscato was injured early and was unable to continue, while Christine Sinclair was stretchered off but was able to return after her ankle was heavily taped. This game, against the mighty Brazilians, will go down as one of the most memorable matches ever played by the Under-19 Team.

Just before the first half ended, Clare Rustad of Salt Spring Island, BC, scored to give us a 1–0 lead. In the change room at halftime, Even told the players they were close to taking control of the game. They could reach the final, but they had to believe in themselves. He grabbed a water bottle from the trainers' table, held it in the air, and addressed the team bluntly: "You have forty-five minutes to put yourself into the World Cup final, or you can walk away with this!"

Canada had played Brazil in our last pre-tournament preparation game in Calgary. In this exhibition game, our team was overwhelmed and intimidated playing against the gold and royal blue traditional colours of one of the world's soccer powers. It took the players sixty minutes to begin to succeed and believe in themselves, but once they settled down, they went on to a 2–0 victory. Once we had learned we could play against and defeat this team, we came to a new level of understanding. It was this belief that sustained us in the semifinal.

In the second half, the intensity increased as Brazil struggled hard to tie the game. Marta, the Brazilian goals-leader, scored in the sixty-ninth minute. I have come to realize that football is sometimes more than life to the Brazilians. Late in the game we were awarded a penalty kick and chaos broke out. The Brazilian players surrounded the referee and the assistant coach ran onto the field to protest the call. During the commotion, he told his goalie that Sinclair might shoot low to the right side. He must have seen her shoot that way in penalty kicks before, but had obviously failed to tell his goalie prior to the game.

Then, when the shot was missed, the Brazilian players swarmed around Sinclair – pushing, shoving and screaming at her. These attempts to intimidate our team should have come at a cost, with perhaps an ejection of a Brazilian, but the Finnish referee was having a hard enough time

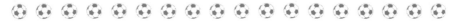

The Brazilian assistant coach Jorcelino Ferreira stormed onto the field to protest a call, confronting the referee and disrupting the game before finally being forced to leave by the referee and security staff.

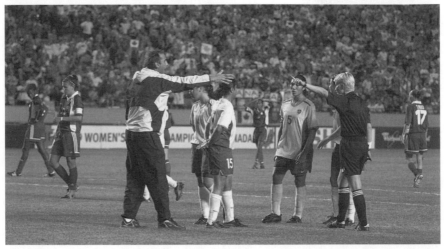

keeping up with the pace and intensity of the game. (After the tournament Brazilian assistant coach Jorcelino Ferreira was suspended for six months from international soccer, and their association was fined $10,000.)

The Canadian players managed to hold their composure, and the game ended in a tie with the winner to be decided by penalty kicks. The penalty shootout was exhausting, and each player had to deal with immense pressure. Marta, the Brazilian star, took the first shot and Erin McLeod made the save. McLeod, with her red and white hair, celebrated by pulling at her shirt and gesturing to the crowd. The whole team fed off her adrenalin – we were in a great position to win the game. Christine Sinclair, Amy Vermuelen, Kara Lang and hometown player Sasha Andrews all scored, sending the crowd of 37,000 and all the Canadian players and coaches into a frenzy.

I remember the pleasure of standing alone in the middle of the centre circle, after the teams had left the field. Commonwealth Stadium was almost empty of fans, excluding the autograph hounds at a corner of the lower side of the bowl chanting the players' names to come out of the change room. Outside the stadium, there were horns honking and loud cheers in celebration for the team. This was a magical experience, and writing this sends chills over my entire body – we had reached the World Cup final.

Sasha Andrews (centre of photo) is surrounded by her teammates after scoring the winning penalty shot in the victory over Brazil.

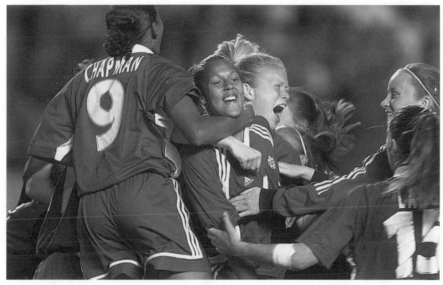

The final against the United States was played in front of 47,784 people in the sold-out Commonwealth Stadium, with an estimated 900,000 more watching on television across Canada. Two special guests were flown in to speak to the team: national team veterans Andrea Neil and Charmaine Hooper. They complimented the girls for reaching the final, and provided insight, motivation, support and encouragement.

In the days leading up to the game, the staff decided the team should play a different formation. The goal was to try and counter three speedy American strikers – Kelly Wilson, Lindsey Tarpley and Heather O'Reilly – who were nicknamed the Triple-Edged Sword. It was a new formation, but we knew the team would be able to learn and accept these tactical responsibilities. This was a major step forward for our program, a result of the time and energy the players and coaching staff had committed to each other over the past two years.

The actual game was brilliant, with both teams having many opportunities to win in regulation time. Once, Ian Bridge and I started to run onto the field in anticipation of celebrating a goal, but it wasn't to be. The game went into golden-goal overtime, with American Lindsay Tarpley scoring the winner in the 109th minute.

It has been more than two years since the game was played, and I still have not managed to review the game tape, or seen the game-winning goal. It would be too painful.

Erin McLeod

Bob Mackin

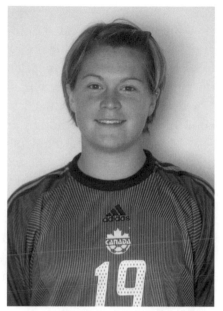

Erin McLeod had a fantastic Under-19 tournament in Edmonton and now plays with the senior women's national team. McLeod also plays with Penn State during the school year and with the Vancouver Whitecaps during the summer months.

When they began playing soccer, some players on the national team were the only girls on otherwise all-boys teams. Goal-keeper Erin McLeod, however, played on an all-girls team in an otherwise all-boys league. "It was a little peanut league. We were called the Pink Panthers," laughs McLeod. "And we got destroyed."

Soccer wasn't always her main focus. She tried tae kwon do and basketball, but in grade nine was faced with the difficult decision of choosing one sport. The sacrifices began earlier: "It started in grade six. People went out to the movies and stuff on weekends, but I stayed back so that I could train in the morning."

McLeod continued to play on club teams until she moved to Calgary. There, she joined city select teams first and then the Alberta provincial team before moving with her family to Jakarta, Indonesia, where her father got a job. Overseas, she played with a boys team for a year, then with a girls team. But the level of soccer wasn't very high.

"That's when I decided to move back to Calgary and live with my grandma. I was only seeing my parents, my little sister and older sister twice a year, tops. That was very difficult for me for the first while, but my family was always really supportive – they knew this was my dream. I made a lot of sacrifices, but it's all been worth it. The soccer wasn't good enough over there, and I wanted to get a scholarship."

McLeod earned the scholarship she wanted, to Texas-based Southern Methodist University, where she played two years before transferring to Pennsylvania in 2004. Off the field at SMU, she found her talent in sketching through a course in advertising.

"There was a project where we had to sketch out and invent our own ad for this certain company. The rest of my group said, 'This is so boring,' but I was up all night doing it. I loved every second of it, and I love school and love learning, but never before had I been so passionate about something in school. I figured if I can draw and also be creative and put that into advertising, that's what I want to do. I fell in love with it, so hopefully I'll stay with it."

McLeod's early role models were American star Mia Hamm ("for opening the world's eyes to female soccer players") and former Canadian international goalkeeper Craig Forrest ("I thought he was absolutely unbelievable"). But it is always her parents whom she applauds for their constant support. "My dad practised with me all the time and my mom would drive me everywhere for practices." She's also been fortunate to have coaches who've understood the value of specialized goalkeeper training, which was never more important than in the 2002 Under-19 Women's World Championship.

In the final game in front of 47,000 people, McLeod had a shutout through ninety minutes, but so did her American opponent. In overtime, Lindsay Tarpley eventually scored the golden goal for the US to take the trophy in the biggest game in Canadian women's soccer history.

"That game was very difficult, one of the most difficult ever, because of how close we came and how hard we worked. At the same time, how can you describe that many people in the stands and that many flags and people supporting you? It was unbelievable what it did for soccer. It's probably one of the best memories of my life." Despite the magnitude of the game, McLeod said it was simple to deal with the

stress. She got in the zone – a mental state in which she concentrated fully on every moment of the game.

"I never felt completely under pressure, I relaxed and had fun, because we all knew we could do it."

A year later, she faced an even bigger challenge – not playing despite being match-ready for the senior women's team.

Coach Even Pellerud decided veteran goalkeeper Karina LeBlanc would start at the Women's World Cup held in the United States. After a disappointing 4–1 loss in their opening match against eventual champion Germany, Pellerud called in Canada's other Albertan goalkeeper Taryn Swiatek, who started the second game against Argentina.

"It was hard to be positive," McLeod says. "But the coaches talked to me and I knew that just keeping the team up was important. I had to fulfill my role that way."

It wasn't a difficult task after all. McLeod and Swiatek were teammates on the Alberta select team, Swiatek the starter and McLeod the backup.

"I'm really glad to be training with her now. She's awesome, a lot of fun and she works hard. It's good to have a teammate like that."

Being a goalkeeper is difficult, because only one gets to play among the starting eleven. McLeod says goalkeepers have to act like a team within the team, offering each other support and playing whatever role is necessary.

"Only one person was going to play – the hardest thing for the other two was not to get jealous, just to be able to have that positive atmosphere. The three of us have meetings all the time, just us. What's important behind the scenes is to be there for each other and to be a good friend.

"I'd go through the same mental warm-up I'd go through if I was going to be playing. Even in warm-up, I was chasing balls or helping Taryn out, constantly visualizing and getting myself ready in case whatever happened happened. I think that's important, and also for KK [Karina LeBlanc], too. You just never knew what was going to happen."

Despite not seeing a minute of game action, it was still a dream come true for McLeod to be at the World Cup. She dreamed of playing on the world stage long before there was such a tournament just for

women. She had to prepare for each game as if she was going to play, because soccer is full of surprises.

Goalkeepers are known for being free spirits, and McLeod is no exception. Though she doesn't profess to have any superstitions, she did wear the same sports bra and same spandex game in, game out. During the world championship, she coloured her spiked hair red and white like the Canadian flag.

"But now that my hair is longer I don't really do that anymore. I listen to my Discman. I write poetry. A lot of my poetry is inspirational stuff or just how I feel before a game. Plus I do a lot of visualization and relaxation. I try not to think about the game until probably half an hour before it starts. Otherwise, I get too psyched out."

Profile

Ian Bridge

Bob Mackin

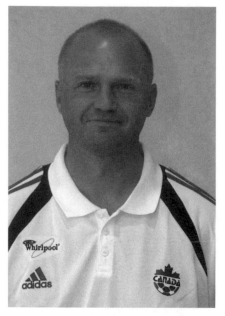

Coach Ian Bridge has helped Canada become one of the world's best Under-19 teams.

Ian Bridge knows what it's like to be a young player on an international team. He once was one.

Bridge played for Canada's youth national team when he was a teenager in high school, long before he anchored Canada's defence during the 1986 FIFA World Cup in Mexico.

"I've gone through a lot of the stages these players have gone through," says the Victoria, BC-born head coach of Canada's Under-19 women's team. Bridge is also an assistant to Even Pellerud on the senior national team's coaching staff. "I understand what it feels like to be sixteen or seventeen and on the road for a couple of weeks."

"It's tough sometimes when you're a young player. You've got school stuff to worry about and you're away from your family in strange places. These are the challenges I can identify with a little better than some other coaches."

Bridge was assistant coach to Neil Turnbull during the 1999 Women's World Cup in the United States and stayed on the staff when Pellerud came to Canada from Norway in 2000. He took a leave of absence

from the University of Victoria, where he had coached the women's team since 1991, to become full time with the national team program.

Bridge played as a pro in the North American Soccer League for five years, including a year with the Vancouver Whitecaps. He also played five seasons with FC La Chaux-de-Fonds in Switzerland and the Canadian Soccer League's North York Rockets and Victoria Vistas.

Bridge's crowning achievement of his playing career was his tenure with the Canadian men's national team. He played thirty-three international matches for Canada from 1981 to 1991, including the 1984 Los Angeles Olympics and the 1986 World Cup in Mexico.

He says he was lucky at all stages of his soccer development to have coaches who taught him the finer points about the game and life.

When he was twelve and playing in division five in Victoria, it was Harold Holroyd and Ron Thompson, both ex-pros from England: "I picked their brains every practice and learned and learned."

Alan Churchard was his next coach, for the Under-19 national team: "Being away from home, with all the challenges you have as a young player – he taught me about controlling what I can control and not other things."

Barrie Clarke was great for the detailed, technical points of the game, helping Bridge become a great passer through repetitive training. It is true: practice makes perfect.

Alan Hinton coached Bridge during his time with the Seattle Sounders and Vancouver Whitecaps: "He was like a father figure to me. When I was a young pro, he really believed in me and made me feel like I was a good player. This gave me a lot of confidence. He was great at motivating teams. With a pro set-up, it's more about keeping things simple and keeping the players happy. That was one of Alan's strengths."

Maybe a first among equals was Tony Waiters, the retired English goalkeeper who came to Canada to coach the Whitecaps and later took Canada to the quarterfinals of the 1984 Olympics, and into the World Cup for the first time two years later.

"Tony's strength as the national team coach was giving the players a simple playing style, believing it and making players happy. You loved to come to camp and play for Tony, see your buddies again, and be together for a week or ten days and play a game. Tony saw to it that camps

were enjoyable and fun. You worked hard, but you wanted to play and win for Tony, for the players and for Canada."

What's the biggest lesson he learned from his coaches?

"The most important thing to have is an effective playing style that the team will understand and believe in. That's been the strength of Even's team, my team and the youth teams – the players coming in understand, to some extent, our playing style."

"A team must have that identity, or playing philosophy, as the absolute bedrock of your program, and that's what you build everything else from."

When Bridge discovered coaching once his playing career was over, he was given the head job at the University of Victoria. At first it wasn't even a full-time job. "I had an opportunity to begin my career. Whether it was coaching men or women I didn't care, I just wanted to stay in the game, the game I loved. I wanted to motivate players to enjoy the game as I did. I wanted to give players that same feeling."

His latest job as coach of one national team and assistant coach of another has given him the opportunity to learn from Pellerud, who guided Norway to the World Cup championship in 1995.

"From Even, I've learned to make my practices, and maybe my goals for the team, much simpler. You need to focus on three things, identify three things you want to work on that you need to win the tournament and don't waver from them.

"I thought, *three things*? Then I figured it out, this is what we need to work on: a direct penetrating attacking style, high-pressure-zone defending and a flat back-four. Every training session and every camp we came to, we didn't work on anything else.

"That was so important in building that strong team. And that was huge advice from Even."

Profile

Kara Lang

Bob Mackin

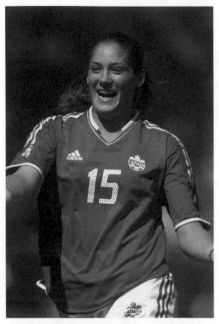

Kara Lang had already played in more than forty games for the senior national team before her eighteenth birthday, scoring twenty-one goals.

When she was fifteen, Kara Lang became the youngest player ever to score a goal in an international game. It was at the 2002 Algarve Cup in Portugal, where she had also earned the distinction of becoming the youngest Canadian to play an international game at the senior level. But it wasn't until that year's FIFA Under-19 Women's World Championship that she really got noticed internationally.

The tall, lanky midfielder and forward plays an aggressive style that she learned in her hometown of Oakville, Ontario. She began playing at age five in a house league and spent six years on the Oakville Angels. By the time she was eight, she had also joined an Under-11 representative team.

"I think I just had more of a competitive personality than most of the kids my age," Lang remembers. "When some of them were there picking daisies, I was there to score goals. That's what was fun for me."

Her height and long arms made her perfect for basketball, just like her long legs and speed did for soccer. For a time, she played high school

basketball and provincial select soccer. When she wasn't studying or playing, she travelled around Ontario for practices and games. Both the basketball and soccer national team programs were interested in her skills. When the national soccer team asked her to come to the tournament in Portugal, she knew the answer was soccer.

Born October 22, 1986 in Calgary, Lang debuted for Canada March 1, 2002 in the Algarve Cup against Scotland and scored her first goal in the next game against Wales in a 3–0 result.

How did she feel after scoring that milestone goal?

"It all happened really fast. I didn't know anything about the record while it was going on, I was just there to play for the experience – to be part of that atmosphere and to train at that level. I had no idea when I scored that goal, but it was definitely an exciting personal achievement for me. Going to Portugal is still one of my favourite memories with the national team. This has become my life now."

The 2002 Under-19 tournament in Edmonton gave her a chance to play in Canada before friends and family, in person and on TV. By the end of the tournament, Lang was a true Canadian sports star, along with teammates like Christine Sinclair and Erin McLeod.

"It was just the biggest surprise ever, walking into that stadium. The first game with 12,000 people in the stands was still the biggest crowd we'd ever played in front of. And it just got bigger from there. It's hard to put it into words still, that whole experience. I'm surprised I can really even remember very much of it. But I definitely made an effort to sit back and take it all in, to realize where I was and what we were doing and what we'd accomplished."

Almost immediately after the tournament, Lang rejoined the senior team for the CONCACAF Women's Gold Cup. At stake was a berth in the 2003 Women's World Cup. Lang says her friendship with assistant captain Andrea Neil made the transition easier. The veteran midfielder showed Lang how to ease into her role on the team, despite being the youngest member. They're also teammates on the Vancouver Whitecaps of the W-League, where Neil is captain and assistant coach.

"She's phenomenal as an overall role model. Not just soccer, it's about life and everything. She's an amazing person, like you could totally learn it all by her example, by the way she goes about her life. At the same time she's there to talk to whenever you want."

Lang found, through trial and error, that she plays best when she's not thinking of the importance of the game. Relaxing and looking forward to having fun is her formula for success.

"I have my best games when I'm not thinking about it, when I'm out there having fun. Fun for me is winning. I eventually realized I still need to be focused, but I can't be one of those players who sits there, zoned out and listening to specific music before a game, with a routine they do to a T. I find if I listen to really high-energy music to pump me up I get too pumped up. Naturally, I've got so much adrenalin that I don't need to do that stuff. I just listen to whatever I want, laugh and joke and try not to think about the game too much or I'll psych myself out."

Aggression is a hallmark of her style. It's been that way since she was little. Sometimes she's not the most skilled or technical player on the field, but she uses her strength and fitness to contribute to the team.

"I know I'm faster or stronger than my defender; I'm obviously going to use that to my advantage. I'm going to use the ball at my feet and my body to turn them, because it works."

After the 2003 Women's World Cup, she had to deal with the most difficult time of her career, as torn cartilage in her right knee was causing a great deal of pain. During the World Cup it began to hurt. She blames it on wear and tear after a busy two years with the U-19 and senior national teams, as well as the Vancouver Whitecaps women's team in the W-League. But rehabilitation is easy if you keep your mind to it:

"I think sometimes when we're not injured we forget how lucky we are to be out there and training. You're definitely reminded every time you have to sit there on the sidelines watching your teammates playing – you want to be playing so badly."

Off the field, her biggest sacrifice has been leaving home and school to play, and still keeping her studies up while travelling the world. Lang says she has always been a very independent person. "My parents were more sad to see me go than I was. I was definitely ready for it. I never got super-homesick. I'm really close with my parents, but at the same time I'm very independent and they trust me and have always given me lots of responsibility."

Despite that, her parents are her number-one role models.

"They've been there since the beginning and they taught me every-

thing. They gave me the confidence to get to where I am now and they allowed me to be independent so I'm able to do things like this, come away to camps or go to places like Portugal at fifteen."

Kara was recruited by the University of California Los Angeles to play with the Bruins, beginning in 2005. She's still wrestling with her fame in Canada, where young girls idolize her play and clamour for her autograph.

"I've always played because I wanted to win, and because I love doing it. I think because I got here *while I* was growing up, it's not like I've always dreamed of being like a role model for a bunch of kids. At the same time I'm obviously going to embrace that as it's fantastic that kids, especially young girls, now have role models in soccer."

For peace of mind, Kara tries to keep her soccer life and social life separate.

"I think it's important to have friends outside soccer. A lot of my best friends and oldest friends don't even play soccer, and knew me before I played on the national team. I'll come home from soccer and we won't even talk about it, that's the way I like it."

When she's not playing, she keeps up on the latest fashion and music news. She might someday want to work for a record company or be a writer for a music magazine:

"I'm into so many different kinds of music and I follow the music industry quite a bit, but I also like a lot of stuff that's not mainstream. That would be really interesting."

World Cup Qualifying: the CONCACAF Gold Cup

Shel Brødsgaard

The CONCACAF Women's Gold Cup soccer tournament is contested every two years by the eight best women's teams in North and Central America and the Caribbean. In 2002, the tournament also served as a World Cup qualifier. Teams were placed in two groups according to their rankings, and met each other once in group stage play. Group A played in the southern California cities of Pasadena and Fullerton, as well as Seattle, Washington, while Group B played in Victoria, BC.

> **Group A:** USA, Mexico, Panama, Trinidad and Tobago
> **Group B:** Canada, Costa Rica, Haiti, Jamaica

The top two teams in each group advanced to the semifinals, held at Safeco Field in Seattle. The semifinal winners moved on to play at the Rose Bowl in Pasadena for the honour of being named Confederation Champion. More importantly, the top two teams also secured a spot in the 2003 World Cup.

The semifinal losers also played a game for third place, keeping their World Cup hopes alive by qualifying them for a playoff with the third-placed team from the Asia group.

The Gold Cup

There was a grand total of six days between the end of the Under-19 Women's World Championships and the start of our preparation for

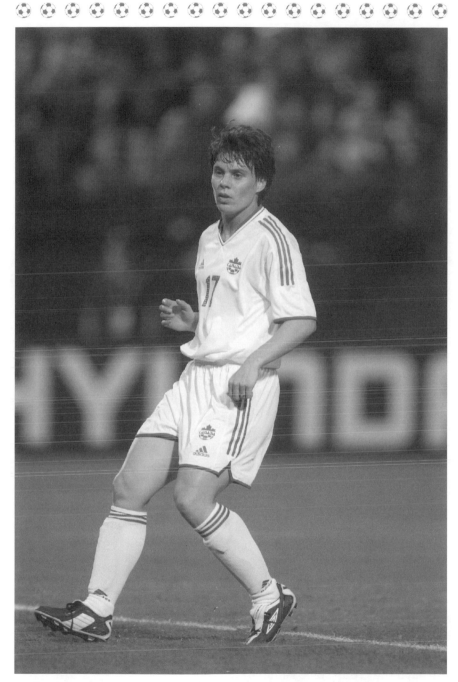

Born in 1969, Silvana Burtini was a longtime national team player with seventy-eight international caps. She retired after the 2003 World Cup (her third) and is now a police officer in Vancouver.

the World Cup team to compete in the Gold Cup. Starting our Gold Cup preparations, the players and coaching staff gathered in Vancouver. Checking into our team hotel, rolling my bags along the corridor to the elevator, I realized that whether as a Canadian men's team player, or a women's team coach, I had been staying at this exact hotel since the age of sixteen. But this time was different. People passing by our meal room reading the sign "Canadian Women's Soccer" were now stopping to peek in and look for familiar faces.

For years, these same people would have walked right past without any interest, but suddenly the stakes were raised. Whenever we arrived at the public training field in Burnaby, and especially on weekends, there were families with young girls and boys calling out the players' names and seeking autographs.

I can remember a few years back, whenever I'd ask groups of young soccer enthusiasts to name a female member of Canada's national team, the common answer was always the American star Mia Hamm. Now the answers could be any one of Kara Lang, Brittany Timko, Erin McLeod, Candace Chapman or Christine Sinclair, or maybe Carmelina Moscato, Clare Rustad or Sasha Andrews. Each of these players had graduated to the senior team, joining Charmaine Hooper, Andrea Neil, Karina LeBlanc and others in the final preparations for the Gold Cup, which also served as qualifier for the World Cup.

Going into the tournament, we knew the two seeded teams in each group were as follows: Canada and Costa Rica in Group A, and the USA and Mexico in Group B.

The top two teams from each group of four would advance to the semifinal. The first place team in each group would cross over to play the second place team in the opposite group.

So, we needed to finish first in our group to avoid playing the Americans. Then, we'd have to beat the Mexican team to reach the final, and gain the coveted World Cup qualification. There was no easy way to qualify for the World Cup. We knew that facing the Mexican team in a one-game playoff would be difficult. But first we had to successfully get through the group stage games.

Our first two games of the tournament were against Haiti and Jamaica. Going into these games was a challenge, as neither team was capable of providing enough competition to test our limits. Therefore, it

was up to our players to motivate themselves to raise their performance, which they certainly did, winning 11–1 and 9–0.

We played our games in late October and early November at Centennial Stadium in Victoria, and the weather was definitely a factor – cold, windy and wet. Our final group stage game was against Costa Rica. Karina LeBlanc earned a shutout, with the final score 3–0. All told, in our first three games we had outscored our opponents by twenty-two goals. Our top goal-scorers were Christine Sinclair with seven, Charmaine Hooper with six, and Kara Lang with four.

Between games, we kept a close eye on the results, starting lineups and on-field formations of the other groups so we'd be ready for our eventual opponents. As expected, the US came out on top, with Mexico in second. We now prepared to relocate to Seattle for our semifinal match against Mexico. We'd be playing at Safeco Field, a baseball stadium built in 1999 that was immaculate. The change room alone was large enough for two soccer teams. The amenities provided in the coaches' lounge and media box were remarkable. Training on the day prior to the game was a pleasure: the soft, flat, green mix of Kentucky bluegrass and perennial rye grass was kept well enough to sleep on.

On the day of the game, we were scheduled to play shortly after the USA–Costa Rica match. There was a spillover effect from the crowd of 23,000, as many stayed to watch. But nothing would have prepared us for the huge numbers of Mexican fans that were singing and waving flags through the entire game. Every move made by the Mexican team – and every mistake by the Canadian team – was greeted with tremendous cheers from the Mexican fans. It was a slightly hostile, but thrilling, environment to play in. Both teams created few goal-scoring chances, but we pressured Mexico into two own-goals for a 2–0 victory.

What an amazing feeling it was to win that game. We were en route to the Gold Cup final at the famous Rose Bowl in Pasadena, California. But more importantly, we had qualified for the World Cup scheduled for China in September 2003.

Oddly, at this exact time, two of our US-college-based players were threatened by their respective coaches to return to school or face the withdrawal of their scholarships. This was a tremendous shock to the team – we were forced to release two players from our roster in the

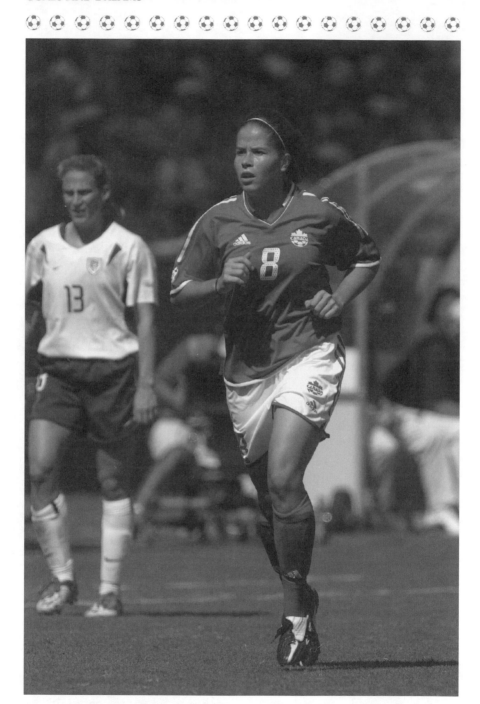

Kristina Kiss, a midfielder from Ottawa, marks star US striker Kristine Lilly. Kiss has travelled the world playing soccer, including a stint for Floya in Norway. She retired after the 2003 World Cup.

final stages of the competition. It was bad timing, and an extremely difficult and frustrating situation for both players involved.

The team settled into our Pasadena hotel feeling satisfied with our accomplishment, but anticipating a demanding and challenging game against the Americans. When the coaches arrived at the Rose Bowl on game day to watch the game for third place between Mexico and Costa Rica, the rain was coming down in buckets. The field was slowly filling with water, and we were expected to play immediately after this consolation game.

By the time we played there was less rain but a slight fog had rolled in, creating unfortunate weather for a Gold Cup final. The Canadian formation was a conservative 5–4–1 which, combined with the sloppy field conditions, was going to make for a long, defensive battle to achieve victory. Tiffany Milbrett opened the scoring for the Americans in the twenty-seventh minute. Charmaine Hooper replied by scoring the tying goal moments before halftime from a corner kick. When it was replayed on the Jumbotron you actually could not see the goal, or who scored it, because of the fog!

The game ended in golden-goal overtime with a tally from Mia Hamm. It is, and always will be, difficult to lose to the American team. But we were another step closer.

Christine Sinclair

Bob Mackin

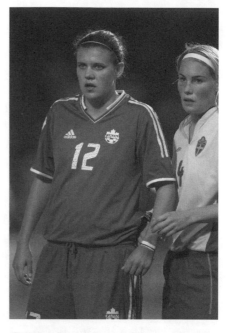

Christine Sinclair is one of the world's top goal-scorers. She helped Canada's national team to a fourth-place finish at the 2003 Women's World Cup. In 2002 she led her college team, the University of Portland Pilots, to a national title and was named Honda Collegiate Soccer Player of the Year. In 2004 she claimed the Hermann Trophy as the top female player in NCAA soccer.

The soccer bug stung Christine Sinclair at an early age. She was just four years old when she joined the Burnabees in the South Burnaby Metro Soccer Club. The rest of the players were six years old.

"I don't think we won a game our whole year," Sinclair says. "When you're younger, there you are – you're just playing around with friends. You don't care if you win or lose."

She would play the game whenever and wherever possible. By the time she was in grade six and just eleven years old, she was playing on the British Columbia select team for players under fourteen.

"It was a challenge. I was still in elementary school and they were

in high school. That was the hardest thing. But on the soccer field, your age doesn't matter. I fit in with my ability."

Christine also started playing baseball at age four, but finally had to make the tough choice to go with soccer alone. That first summer on the provincial team, her coach Keith Puiu told her she'd someday be on the national team.

"He didn't tell me I'd be sixteen years old and on the national team. It was the first time it occurred to me that there's a future in the game." She went with the provincial team to California to play high-level teams in tournaments, and got a taste of what soccer could be.

"That first trip we went to San Francisco and Los Angeles, it was pretty good. We were a provincial team playing club teams from the states and they were giving us good games. It was a lot different than playing club back in Burnaby."

Of course it didn't hurt that her uncles were star professional players Bruce and Brian Gant, veterans of the the North American Soccer League. They also played for Canada's national team.

"To me they're just family. Everyone else says, 'Oh, you must be so lucky to have professional athletes as uncles.' They're just my uncles. I didn't see them as being professional soccer players."

In elementary school, Christine had time to play basketball, baseball and soccer, but in high school it was all soccer and all studies. Soccer was like a carrot on a stick. Get your homework and studies done in a quality manner and you'll get a chance to play the game you love.

"You find time and get your work done. If you don't get it done, the only option is not playing."

After high school she earned a scholarship to Portland University where, after only two years on the team, she became the top goal-scorer in the school's history . . . not to mention scoring the goals that won the school its first national championship in any sport. That was the highlight of her career, so far, she says:

"It's definitely one of the harder things to do in the game, but goal-scoring comes easy to me. It just seems like some players when they're in front of the net, it's like there's a brick wall in front of the goal and they can't do it. I've never had that problem. The goal is so big and there's only one person in the middle of it. That's the way I see it."

Sinclair was born in Burnaby on June 12, 1983, and debuted with

the national team in a 4–0 loss to China in Portugal's Algarve Cup on March 12, 2000. Two days later she scored her first goal in a 2–1 loss to Norway.

Sinclair says her secret is simple. Anticipate where you think the ball is going and where you think the defender will go. Try to beat the defender to that space for a chance to shoot at goal.

"It's all instinct. I don't really think out there, it just happens." Indeed, she made it look easy when she was the top goal-scorer during the first FIFA Women's World Under-19 Championship in Canada. Her touch helped Canada make the final, a heartbreaking 1–0 overtime loss to the United States.

The summer of 2003 was notably more difficult, as Christine suffered mononucleosis, had her wisdom teeth removed and suffered the loss of her Portland coach Clive Charles to cancer. She says he was more than a coach – he was a friend and mentor.

"He was an amazing man, the best coach I've ever had. He was a friend to all his players: he cared so much about them as people and what they were going to do when they were done university. He was more concerned with that than winning national championships and games."

He taught her that the most important thing about the game was to have fun.

The team wasn't the best or most talented in the country, "but we were all out there working so hard for one another, working so hard for him, and having fun. It's amazing what that can do for a team."

Another of Christine's dreams came true in the Women's World Cup. Only four years earlier she went to some of the games in Portland as a spectator, dreaming of being on the pitch. In Columbus, Ohio, she scored Canada's first goal against eventual champion Germany. She also scored the team's last goal against the United States in the bronze medal match. She got to play twice in Portland, in the very stadium where she dreamed of playing in the biggest women's sport tournament in the world.

"I'm lucky enough, the pressure doesn't get to me. Playing soccer, it's all fun to me. Playing in the World Cup was not stressful. It was enjoyable. Some people do get very nervous. I've never had to deal with that."

Christine made sacrifices, such as taking the semester off her studies, in order to play in the World Cup. When she wasn't with the national team, she returned to Portland to practise with her teammates and relax.

"Being away, especially in university, forces you to be very organized. If you look at these players on the team, they're all doing very well in school. If you don't do well, you won't be here. I have great teachers who are pushing me. They know my future is in soccer, but they also care about my education. They know who I am."

When she's on the field, she feels the most important thing is to stay focused and understand her role in the game – even when it's obvious opposing players aren't playing by the rules.

"It's all about keeping your head on straight. You're going to go up against players that will want to kick you and tug on your shirt. I'm not one to do it back because then you're stooping to their level. I'll beat them in a different way."

Referees, she says, don't deserve extra pressure from players complaining about the opposition or quality of the calls.

"There's no use yelling at them, because then it seems they'll hold a grudge against you. That's the way I see it. They're just like players, they know when they made a mistake and they don't need to hear about it. I just play the game and leave the ref out of it. If you're focusing on the ref, then you're focusing on the wrong spot."

Despite her love for the game, she likes to leave soccer on the field.

"If you live and breathe and all you think about and all you care about is soccer, then you're going to burn out in a matter of weeks. When I'm away from the game, I'm away from the game. I'll watch it on TV, and things like that, but I don't think about what I'd do. I try to live a normal life when I'm not on the soccer field."

Profile

Charmaine Hooper

Bob Mackin

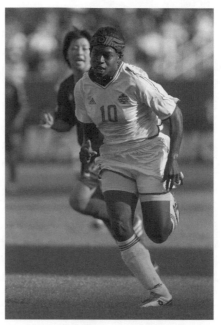

Charmaine Hooper is Canada's career leader in games played and goals scored. One of the world's top players, she has twice been named to the FIFA World All-Star team.

Every day Charmaine Hooper plays soccer is another day she can fuel her passion.

"I'm obviously thankful for everything I've been able to do with my sport," says Hooper, who was born in 1968 in Georgetown, Guyana.

Hooper began playing soccer by the time she was nine years old in the schoolyard in Lusaka, Zambia. Her father, a Canadian diplomat, had moved the family to the African country. Charmaine regularly joined her brother Lyndon and his friends in kicking the ball around. She was always trying to be as good as, if not better than, the boys.

"I never knew any different. I was always the only girl playing with the boys. We'd play for fun in the schoolyard, waiting for my parents to pick us up. I'd be in a dress or skirt, just whatever I wore to school."

Her father made the sacrifice of resigning from the diplomatic corps to return to Canada, to give Charmaine and Lyndon better

opportunities for schooling. She joined her first all-girls team when her family moved to Nepean, near Ottawa, when she was twelve.

During Ottawa's long, cold winters, she played soccer in gymnasiums. When it got warmer, she moved outside to play at parks and school fields. As she got older and better, she travelled to Toronto on weekends to train with the Ontario provincial team, sacrificing her social life in order to be the best she could be. She met more friends through the game, which offset any friendship losses at home.

"The good thing about a soccer team is you always right away have eleven players, or more, who are like your friends. I can't say you're going to be best friends with them all, but at least you have people you can develop a relationship with. That's always positive."

Hooper progressed to the point where she was picked for Canada's first national women's team that played two games against the United States in Minnesota in July 1986. She played in Canada's first international game and scored one of the first goals. It was the start of a long journey for Charmaine and her teammates, through good times and bad. There were many bad times, because the team lost more games than it won – especially internationally at two previous Women's World Cups.

"My worst experiences have been the first thirteen years of my soccer career with the national team, and I would say the best experiences have been the last four years."

Her skills and hard work paid off with professional contracts to play in Japan, Norway, Italy and the United States. She was also the star striker with the Atlanta Beat of the Women's United Soccer Association.

Because of the lack of international success in the early years, Hooper has learned how to deal with losses, and savour wins even more.

"I've lost many big games, probably more than I've won. I'm very disappointed, but at the same time I have to tell myself it's not the end of the world and there's so much more to life than a soccer game. Losing a game is really not that big a deal when you look at what life is all about. That's one way I can deal with losses."

Hooper says it's important to develop a winning attitude on and off the field. If you don't have that attitude, you shouldn't be playing.

The greatest win of her life was the 1–0 result over China in the quarterfinals of the 2003 Women's World Cup in Portland, Oregon. Early in the match, she emerged from her position on defence to head a cross from Diana Matheson into the Chinese net for the only goal of the game.

During the tournament, Hooper was all over the field, helping out wherever she was needed. She started as a defender, because she was needed there the most. A series of injuries kept regular starters at home in Canada or on the bench, not yet one hundred percent ready to play. Before the summer of 2003, Hooper had never played on the backline during her outdoor soccer career. She took the challenge with grace, because sometimes sacrifices need to be made for the good of the team.

"As a forward, of course you feel pressure to score goals and help your team win. As a defender I didn't feel that same kind of pressure and anxiety before games. This is really weird, because I thought, 'Well, is it because defence is supposed to be easier that I'm so relaxed?' Forward is a much more difficult position, you're trying to create and score, whereas defence you're trying to disrupt forwards from scoring – you don't have to be as dynamic, you can be creative in a different way."

When she's not playing the game, Hooper is resting, relaxing and exercising, making sure she's fit to play the next game. She drinks lots of water – she's always the one with the biggest water jug at training. When she's not with the national team, she likes to train children. Hooper and her husband Chuck had their first child, Charlie, in early 2005.

"I also enjoy cooking or baking, which, when I'm very busy, I never find time to do. And just relaxing, really, with my computer. That's really it. I'm very low-key. I don't do very much as far as going out. With what we do and when I'm playing on my team, we train every day and the last thing you want to do is go out walking around and being on your feet. You're constantly trying to recover, day after day, that's a challenge in itself."

As captain of the team, she's always answering questions from reporters and commentators who sometimes criticize her and her teammates, especially when they make mistakes during a game.

"I'm happy to be a role model, I understand that I'm a pioneer in my sport, and I'm grateful to have that honour. I've been through a lot, definitely been through a lot. It's good to have younger girls look up to

me. The most I can do is do my part to set a good example on the field and off the field and just demonstrate what it's like, or should be like, to be a professional."

Hooper says the biggest benefit of representing her country and playing professionally is the sense of well-being and the friends she's made along the way. She loves experiencing the roar of the crowd and the excitement of facing challenges, and travelling around the world to play the game she loves so much.

"It's good to experience all those different levels of excitement, I think, and you learn from it all."

The Road to the 2003 Women's World Cup

Shel Brødsgaard

The team members went their separate ways after the Gold Cup tournament: some back to their studies and college or club soccer teams, a few back to high school, and others back to their everyday working lives. But each player had a training regime to work on, with a specific program to follow until the national team gathered again.

Each March in Portugal, the team competes in the Algarve Cup, an informal tournament that essentially brings together the best international women's soccer teams. In 2003, we were able to play or scout Norway, Sweden, China, France and the USA.

Each day the team would train at the fields provided by the hotel, watching the competition as we passed by, and enjoying the European soccer culture: soccer practices by day and European-league soccer on television each night. All of this, mixed in with high-level games, was an excellent opportunity to develop as a team. In our game against the USA, Andrea Neil scored early and we pushed them right to the limit. A late equalizer gave them the tie, and they were lucky to get away without a loss.

Inch by inch, step by step, we were closing the gap between the past, present and future of Canadian women's soccer. We also came away with an impression of the Swedes, who at this time had a threatening player by the name of Hanna Ljungberg. Although she is five-foot-three, she seemed six feet tall on the field; her play was intimidating, strong and powerful, and she produced goals. We also noted the goalkeeper's speedy transitions from defence to offence, which produced

The team huddles at halftime.

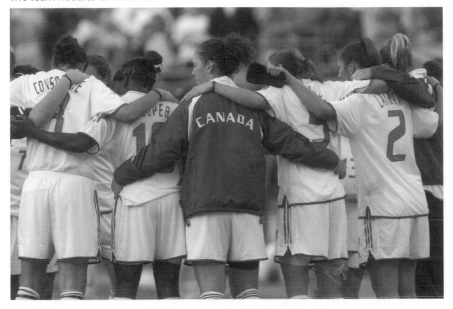

an excellent counterattack. The Norwegian team didn't seem as strong as the Swedes, but it always receives a certain level of respect earned by its historical results. The final featured the USA and China, and it was pleasing to see the Chinese team in action, as it showed that it was beatable.

In April the US was scheduled to play Nigeria, who would then travel to Canada to face our senior national team. But when Nigeria failed to show up, we were called in at the last minute to play the Americans in Washington, DC. We flew in as many of the regular or starting team as possible, but there were conflicts with the Women's United Soccer Association (WUSA). As a result, a number of our players who were competing for final spots on the World Cup team roster were recruited. Although we lost the game, it created a great opportunity for more exposure for players such as Rhian Wilkinson who were seeking to boost their case for selection to the women's national team.

At the game, the assistant coach of the Washington Freedom approached me wanting to contact Nicole Wright. The Freedom was seeking a backup goalkeeper for its upcoming WUSA season, and Wright was a former Canadian national team goalkeeper with close to forty international caps. She eventually signed with the team, and experienced

the life of a professional female soccer player in the United States. Wright joined a long list of Canadian players such as Charmaine Hooper, Sharolta Nonen, Breanna Boyd and Christine Latham who benefited from experience in the American professional league. The WUSA provided an extremely competitive environment for these players to face the best players in the world, and the opportunity to train and compete on a day-to-day basis in a professional atmosphere. Unfortunately, the league folded in the fall of 2003 and its future rebirth is somewhat uncertain.

Due to the ongoing success of the national team, the Canadian Soccer Association (CSA) was able to secure a packed exhibition schedule against some of the top teams in the world in the months leading up to the World Cup. These games – against England, Brazil, Mexico, Ghana and Australia – were watched by more than 90,000 Canadian fans.

In May, we played our first exhibition series against England, with games in Montreal and Ottawa. Both results were 4–0 in our favour. Kara Lang scored two goals in each game, Andrea Neil totalled three, and Taryn Swiatek and Karina LeBlanc each had a shutout. I remember a discussion with a member of England's coaching staff after the second game. He mentioned that it was good for them to get games against one of the best teams in the world, as this helped them develop and close the gap that they felt separated them from us. We had been experiencing this same scenario for years as we faced the Americans; yet, here was an outsider giving our team the confidence and respect rarely handed to us before.

In June, we travelled south to play Mexico in the coastal cities of Mazatlan and Guasave. I fondly remember walking into our beachside hotel and feeling the fresh sea breeze blowing through the open-air lobby. It was energizing. The players found the pool and marvelled at the beach.

The first game was played in Guasave, a small city a few hours by bus from Mazatlan. The game was interrupted when the stadium lights shut down for twenty minutes in the middle of the second half. All you could see were fires burning in metal drums behind the stadium where vendors were selling snacks and drinks. Because it was an exhibition game and we were allowed five substitutions, sixteen different players contributed in the 4–0 win.

The second game was played in a baseball stadium in Mazatlan. Unfortunately, the pitch was as hard as a shopping mall parking lot. But the team managed to avoid injury and won 2–1. We spent the final few days in Mazatlan relaxing on the beach, enjoying the local food and glorious sunsets. It was a well-deserved break.

The next two-game series, in mid-July against Brazil, was thrilling. It was also at this time that Robbie Hart introduced himself. He would be filming and interviewing players for a made-for-TV movie focusing on the team named *It's a Great Game!*

The first game was played at Molson Stadium in Montreal, in front of more than 12,000 fans. The Brazilians feature two formidable midfield players, Marta and Formiga, who both love to attack one-versus-one, but we managed to contain them. Brazil scored early in the second half, but Rhian Wilkinson tied it in the sixty-seventh minute, scoring her first international goal. There was controversy late in this game when a Brazilian defender struck one of our players following our late game-winning goal by Randee Hermus. The Brazilian player was red-carded, but allowed to play in the next game because these games were exhibition. There is no love lost between these two teams.

In our game in Ottawa a few days later, more than 18,000 fans were on hand for the rematch. Brazil scored an early goal, but Kara Lang tied it just before the first half was over, and Randee Hermus scored her second consecutive game-winning goal as we won 2–1.

The Ottawa win was our sixth in a row, and the momentum building around the team was very noticeable. There were young fans seeking autographs, and the number of requests for team and individual appearances was constantly rising. Each day the players were challenged to keep their focus on the game.

The players were released to their respective WUSA and W-League teams during the gaps in our schedule. Randee Hermus and Kristina Kiss were flying back and forth to Norway between games. They were playing for Floya in Tromso in the Norwegian women's first division, an arrangement that had been made when their coach scouted our players in the Portugal tournament. Many team members were living away from home, committing all their time and energy to making the final roster of the World Cup team.

Between the two Brazil games, the coaching staff gathered to

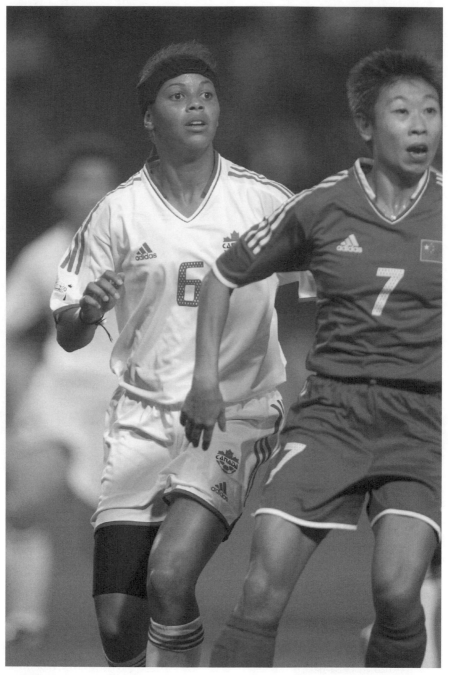

Sharolta Nonen, a defender from Vancouver who played professionally in the WUSA with the Atlanta Beat, is shown here marking China's Bai Jie, one of the world's top players.

watch the World Cup draw to determine the pool groupings and schedule, which was being televised live from the Home Depot Stadium in Carson, California. We found ourselves very fortunate to end up in a group with Japan, Argentina and Germany. Finally – we had actual opponents to focus on during our preparations.

In August, the team reunited in Vancouver for what would serve as the last opportunity for players to prove themselves before the final roster of twenty players was selected. First, there was a short trip to Seattle for a game against Ghana, which ended 1–1. Then we moved on to Kelowna for additional training, plus some fun team-building activities like golfing, go-kart racing, and touring the lake in a houseboat.

Our stay was interrupted, however, by the wildfires burning throughout the area. We were denied access from practising in the Apple Bowl because military reserves had to use it as their base to fight the fires. Here we were, right in the middle of a natural disaster, trying to secure training times and fields, while people's houses were burning to the ground. The team found it very easy to pull together, offering their

Canada and Brazil have had some legendary battles over the years. Here, Christine Sinclair appeals for a penalty.

rooms to firefighters and displaced families. As quickly as we could, we boarded a bus and headed for the airport as the fires burned – they continued to do so for several more weeks.We flew directly to Edmonton, where we were scheduled to play Mexico in Commonwealth Stadium. The local organizing committee put on a fantastic benefit dinner for the team that celebrated their accomplishments. The game was scheduled for August 31, 2003, on the first anniversary of the 2002 FIFA U-19 Women's World Championship final. There were almost 30,000 spectators for this exhibition game, which we won 8–0. Seven different players scored.

The second game of the series was played in Vancouver, where our younger players scored all the goals in a 6–0 shutout win: Kara Lang with three, and singles by Rhian Wilkinson, Sasha Andrews and Clare Rustad.

Shortly after, the team dispersed for six days prior to meeting in Kingston, Ontario, for our final exhibition game. We concluded our months of preparation with a 2–0 win over Australia, on goals scored by Charmaine Hooper and Rhian Wilkinson.

Since May, we were on an amazing ten-game undefeated streak heading into the World Cup. But serious injuries were now starting to take their toll. Three defenders under consideration for our starting four were now sidelined, and we weren't certain when, or if, they would return. Breanna Boyd was still out with a concussion suffered during a WUSA game in June; Candace "Chappie" Chapman had suffered a knee injury during a scrimmage game in Kelowna; and Randee Hermus was nursing a stress fracture that we were all hoping would improve in time for World Cup action.

In the three years that I'd been involved in the national program, we'd never lost so many players in the same position at the same time. Especially worrisome was how the team would adjust to the loss of three crucial defenders.

Profile

Diana Matheson

Bob Mackin

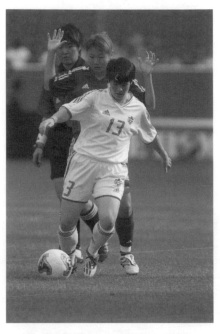

*Midfielder Diana Matheson has shown
herself to be a strong and confident player.*

Diana Matheson is a speedy midfielder who plays much bigger than her actual height, five-foot-two. Growing up in southern Ontario, she began playing house-league soccer and graduated to the Oakville representative league by age ten. Matheson spent her winters playing hockey and only hung up the skates when she joined the national soccer team. But she may never have played soccer at the highest level without first learning to overcome the physical challenges she faced while playing hockey.

"You're used to it when it comes to soccer, especially on this team, because it's so physical. That would be the main thing. It's just never really bothered me at all, I went out there and played, and it didn't matter if they were taller – it just doesn't make a difference when you're playing. Maybe it's because smaller players are usually a bit quicker."

Matheson was born on April 6, 1984, in Oakville and now studies mathematics and sciences and plays at Princeton University in New Jersey. She made her national team debut less than eight months before the 2003 Women's World Cup. In her first game at the Algarve Cup in

Portugal on March 18, 2003, she was called upon as a substitute against Norway.

"I was nervous going in, very nervous," she remembers. "I was so excited when I got in my first game that I just sprinted on the field. People say Even [Pellerud] was calling me, but I didn't hear him, I just ran on."

During the months leading up to the World Cup, Canada played Mexico four times, including once in Mexico. That was the game in which Matheson scored her first goal.

"We were short a lot of players for that game, because they'd gone back for WUSA or school. We were down one goal at the end and Even told me to push up higher, and I did." As she often is, Matheson was at the right place at the right time.

Her experience throughout 2003 taught her to relax, focus on improving any physical weaknesses, and eat well on game day so that she can go "all out" for ninety minutes or more.

"I've actually been pretty lucky during my career not to be injured very seriously. I keep fit with weights and training. And a little luck."

During the World Cup she improved her communication skills, game by game. "It never hurts to talk more and just talk to the people who might be playing defence, try to get things started that way."

The injuries of teammates forced her to dig a little deeper and run a little harder.

"It was tough, because you would finally set up a line or a back four and then someone else would get hurt and you'd have to put another person back there, maybe another midfielder. You just have to keep playing. It definitely affected how the team played, with different individuals back there, but the play was pretty much the same."

The team started the tournament in disappointing fashion against Germany, and then recorded a non-convincing win before finally meshing against Japan. The transformation came after a team meeting in which Andrea Neil rallied the troops with the choice of two routes: go home and consider the four years until their next chance, or play to be in the final four and make Canadian women's soccer history.

"There's nothing or now," she remembers. "Going into the China game we had so much confidence. Through that game and at halftime, we just knew we were going to win this."

At halftime, Matheson was able to reflect upon her role in the biggest Canadian goal ever – scored by Charmaine Hooper on a header in the first ten minutes:

"I was somewhere on the left side. The ball actually bounced back to me and I crossed it in. It was an unbelievable moment, I can't even remember how I felt, I just ran in towards her. I remember looking at the clock with eighty minutes left and knowing we were going to win. Our defence was clearing everything out and we had great shape all the time and I just knew we were not going to let them score."

Profile

Rhian Wilkinson

Bob Mackin

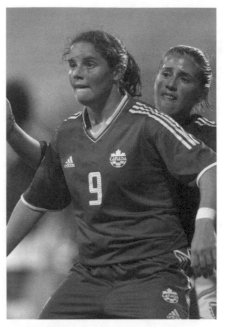

Rhian Wilkinson, here marking an Argentine player, can be counted on to give the team a boost of energy.

The most rewarding part of being on a team is the feeling of unity, says Rhian Wilkinson.

"Nothing beats the feeling of winning a close game when you've given everything you have, and you know everyone else has. That feeling is second to none," she says.

Wilkinson scored her first goal as a national team member in front of her family, friends and 12,000 fans at Molson Stadium in her hometown of Montreal. It was the tying goal in an exhibition game against Brazil in July 2003, during the buildup to the Women's World Cup.

"It was something out of a fairytale, an amazing experience. I'll never forget that."

Wilkinson became known during the World Cup as the "super sub." On a team already depleted by injuries, coach Even Pellerud often called upon her at key moments to enter the game as a midfielder or forward and, with her fresh legs, to give the team an energy boost.

"I know a lot of people have trouble or don't like being on the bench.

But I look at the forwards this team has, including the two Christines [Latham and Sinclair] and Charmaine [Hooper], and all of them are so good. So, just for me to get in the game is huge. I don't care that I don't start. When I get in all I know is that I have to work hard because everyone's so tired. For me it's just pure excitement."

Her father, Keith Wilkinson, a former national rugby player and coach in Canada and Wales, taught her to visualize. Or, as she says, to "put yourself in the game before you get in there."

"You can't afford to be a step behind when you get in," she says. "On the way to soccer practice he used to sit and talk about what was going to happen and how you have to picture it in your head."

Her father also helped her understand how much work, passion and commitment is required to play at the highest level of a sport. She learned about speed and aggression by playing rugby, but chose to focus on soccer instead. Except, when she first started, there weren't any girls to play with.

"That was tough mentally, playing on a boys team and not getting the ball. They'd dribble around you instead of passing. That was tough at first, but after a while I just started taking it off my teammates."

Wilkinson, an English and communications student at the University of Tennessee, suffered a cracked bone in her left foot during her sophomore season. It gave her a chance to rest mentally and physically, and to learn more about the game. She joined the team staff in 2004 as a student assistant coach.

When she doesn't play or coach soccer, she laces on skates at home and plays hockey or does some figure skating. She also loves music, and plays both cello and trumpet.

Her weekly ritual includes watching English Premier League soccer on Saturdays. Analyzing the skills of some of Europe's best players, like Michael Owen, helps her improve her own skills.

"The control they have, the touches you see, they're so relaxed on the ball. That's something I really need to work on. And, to get myself into scoring position. A lot of times I won't always put it away, I'm not like Sinky [Christine Sinclair], who is totally consistent. I really want to follow in her footsteps, to be as emotionally controlled as she is on the field. That's what the top scorers do so well, finish every opportunity they get."

One of Wilkinson's pre-game rituals is to tape her wrists and put tape around her ring, rather than take it off.

"I do the same things before every game: take the necklace off and put it around my watch, earrings out; then write on my wrist on a piece of tape; then just listen to music."

She's been taping her wrists since starting university. She dutifully writes "Scrapper" – her freshman-year nickname – on one wrist. On the other is the number ten.

"I won't score the beautiful goals, but I work hard and get my toe in if I need to. The number ten on my wrist is for when I'm really tired. I remember the ten and that there's ten other people on the field with me, so I'll play for them. It reminds me constantly that I'm not out there on my own."

The World Cup Group Stage Games
Shel Brødsgaard

The World Cup tournament occurs once every four years and hosts the top sixteen teams from around the world. The tournament was initially scheduled for China in 2003, but due to the outbreak of Severe Acute Respiratory Syndrome (SARS) a decision was made to protect the health and safety of the teams and spectators by relocating to the United States. There were thirty-two matches played in total, at the following stadiums: RFK in Washington, DC; Gillette Stadium in Foxboro, Massachusetts; PGE Park in Portland, Oregon; the Home Depot Center in Carson, California; Columbus Crew Stadium in Columbus, Ohio; and Lincoln Financial Field in Philadelphia, Pennsylvania.

> **Group A:** USA, Sweden, North Korea, Nigeria
> **Group B:** Brazil, Norway, France, South Korea
> **Group C:** Germany, Canada, Japan, Argentina
> **Group D:** China, Russia, Ghana, Australia

The top two teams in each group were to advance beyond group stage play, into the quarterfinal knockout stage of the tournament. A total of 680,000 spectators viewed these games live, with television coverage extending worldwide. The final was watched by more than two million people in Sweden alone.

For Canada, there was a tremendous advantage to playing the World Cup tournament in North America rather than in Asia. While it would have been exciting to be in China, everything would have been

a challenge: the language and climate; the food; the time difference; the air quality, traffic and transportation; the scenery and local customs; the media; the fans . . . So, when the host country was changed due to the SARS outbreak, we benefited tremendously.

In the United States, it was easier to remain comfortable in your surroundings because everything was familiar. We had less travel; familiar food and stadiums; local media; and English was the spoken language. As well, family and friends would find it much easier to travel to the games, or else could watch them on television. All told, it was a lot less complicated to play in the familiarity of North America rather than travel across the world to an entirely different culture.

Finally, we were on the way to Columbus, Ohio, where we would train for five days and then play our first two World Cup games. The facilities and resources provided by the professional infrastructure in the USA made an immediate impact. The training ground and stadium belonged

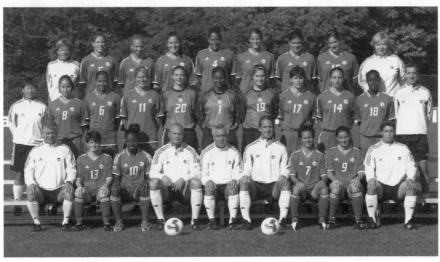

At the Columbus Crew training grounds, as we prepared for our group stage games.
Front row, from left: Jamie Fales (equipment manager), Diana Matheson, Charmaine Hooper, Ian Bridge, Even Pellerud, Shel Brødsgaard, Isabelle Morneau, Rhian Wilkinson, Paulo Bordignon (physiotherapist)
Middle row: Holly Mair (massage therapist), Kristina Kiss, Sharolta Nonen, Randee Hermus, Taryn Swiatek, Karina LeBlanc, Erin McLeod, Silvana Burtini, Carmelina Moscato, Tanya Dennis, Morgan Quarry (media relations)
Top row: Dr. Cathy Campbell, Andrea Neil, Brittany Timko, Christine Latham, Sasha Andrews, Linda Consolante, Christine Sinclair, Kara Lang, Kim Sebrango (manager)

to the Columbus Crew from Major League Soccer (MLS). After three and a half years of preparation, we were here to prove not only to ourselves but also to the entire world that our program could compete with the best. To walk out on the pitch every day wearing your country's colours and preparing to face some of the other fifteen best soccer teams in the world is a unique feeling and a special accomplishment.

In order to prepare for these first group stage matches, the coaches had viewed hours and hours of our opponents' game tapes – almost every game they had played in the past six months. By the time we saw the opposition practising at the stadium the day before the game, I was able to recognize and name the players because we'd seen so much of them on the tapes. The Canadian players were confident in this stadium because it was the same venue where they'd beaten the USA for the first time a couple years earlier.

I remember warming-up goalkeeper Karina LeBlanc for the first game against Germany. Right behind the Canadian goal was a giant video screen showing a collage of soccer highlights while the song "Time After Time" by Cyndi Lauper was playing. Because it had been one of my favourite songs in junior high, I found it comforting to hear each time we started the pre-game warm-up. This became kind of a ritual for the tournament, and it always brought a smile to my face, warmed my heart and allowed us all to relax a bit.

Canada versus Germany
September 20, 2003, Columbus, Ohio
Attendance 16,404

Starters: *Karina LeBlanc, Christine Latham, Andrea Neil, Sharolta Nonen, Kristina Kiss, Charmaine Hooper (captain), Christine Sinclair, Diana Matheson, Kara Lang, Brittany Timko, Tanya Dennis*
Substitutes: *Rhian Wilkinson (46th minute) for Lang*

Our first opponent was Germany, who entered the tournament as one of the favourites. Germany has a well-established national women's league, and many well-known star players like goalkeeper Silke Rottenberg, striker Birgit Prinz and their captain Bettina Wiegmann. As well, two of their former greats, Maren Meinert and Steffi Jones, had come out of retirement for one last shot at winning the World Cup.

Our goal was to start with a solid performance against the Germans. In the fourth minute, we scored a brilliant goal from a free kick. Kristina Kiss provided service to the back post for Christine Sinclair, who headed the ball down and past the German goalkeeper. 1–0 Canada. To take an early lead against one of the best teams in the competition was remarkable.

In hindsight, we may have woken the sleeping giant! Not only did the game end 4–1 for the Germans, but we also missed several scoring chances that would've kept the score closer. The mood of the team could also have been better: losing is never easy, but how you perform in that loss is what matters most. We had hoped to enter the second game against Argentina with a good feeling, regardless of the result from the opening game against Germany. Unfortunately, nobody felt like she had played to her potential.

Leading up to the tournament we were undefeated in ten games, downing England, Mexico and Brazil along the way. Everywhere we turned, people asked, "How good is your team?" but the only way to answer that question was to perform well in the World Cup.

Canada versus Argentina
September 24, 2003, Columbus, Ohio
Attendance 15,529

Starters: *Taryn Swiatek, Christine Latham, Rhian Wilkinson, Sharolta Nonen, Kristina Kiss, Charmaine Hooper (captain), Christine Sinclair, Diana Matheson, Kara Lang, Brittany Timko, Tanya Dennis.*
Substitutes: *Silvana Burtini (75th minute) for Wilkinson; Sasha Andrews (83rd minute) for Latham.*

Light training sessions are often held in the days between games, where the starting eleven recover and the substitutes do additional work to keep game-fit. After the match against Germany, we practised in a heavy rain and Andrea Neil strained her groin, forcing her to miss the next game against Argentina. In addition to facing the disappointment of not playing, she would also have to recover while the tournament was happening. Injuries are always stressful for any athlete, but even more so when they happen in the midst of a World Cup – some of the women had trained four years to get there.

For our second game, we remained in Columbus to play Argentina. We needed to rebound from the disappointing first loss and take three points and the win. Going into the tournament, the coaching staff had discussed designating Karina LeBlanc as the starting goalkeeper, but we'd also talked about using another goalkeeper against Argentina. We felt that it would be a low-intensity game for the keeper, meaning that there wouldn't be many shots or interaction with the back-four defenders. The mental challenge for the goalkeeper would be to stay tuned-in and focused on the game.

Erin McLeod had been the most energetic and motivated. Karina LeBlanc was the most athletic and powerful. Taryn Swiatek had been the strongest mentally, and was coming off an exceptional tournament for Canada in the Pan-Am Games held in the Dominican Republic.

Coach Pellerud decided on Swiatek. Rhian Wilkinson also entered the lineup in place of Neil. Charmaine Hooper scored on a penalty kick in the seventeenth minute, and Christine Latham scored two goals in the second half for a comfortable 3–0 win.

It was Canada's first-ever victory in a World Cup tournament. In most circumstances, you would expect to hear some form of celebration from the women recognizing this accomplishment. But the team

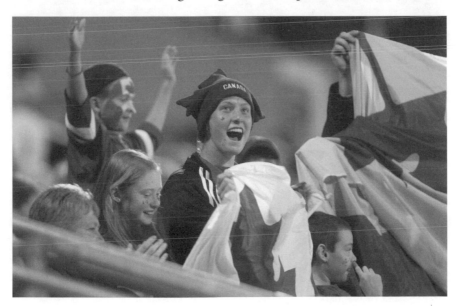

Canadian fans of all ages cheer at the game against Argentina.

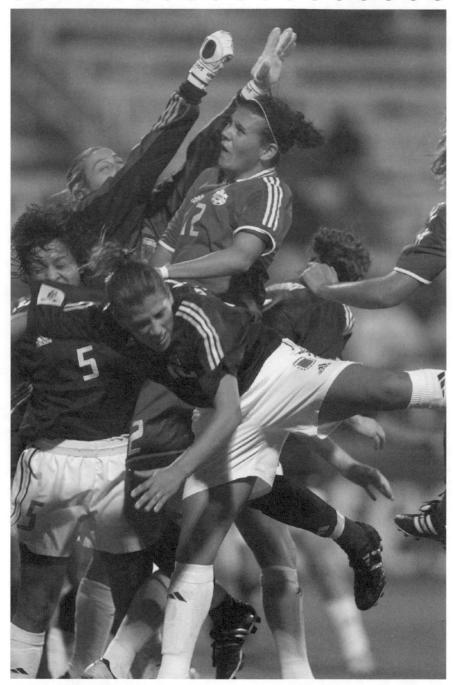

Christine Sinclair (12) attacks Argentina's goal after a corner into the crowded six-yard box.

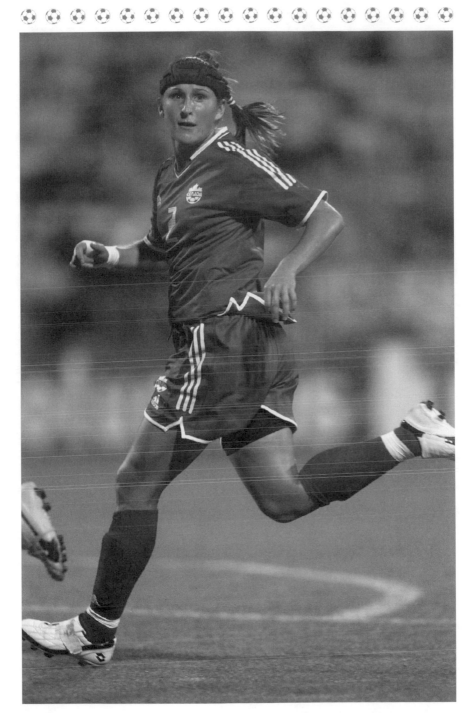

Christine Latham was another Canadian who had a fantastic World Cup, scoring three goals in three games during the round-robin matches.

knew they still had not performed up to their potential – even with the victory there was silence.

Canada versus Japan
September 27, 2003, Foxboro, Massachusetts
Attendance 14,356

Starters: *Taryn Swiatek, Christine Latham, Andrea Neil, Sharolta Nonen, Isabelle Morneau, Charmaine Hooper (captain), Christine Sinclair, Diana Matheson, Kara Lang, Brittany Timko, Tanya Dennis*
Substitutes: *Silvana Burtini (60th minute) for Latham; Kristina Kiss (77th minute) for Neil; Rhian Wilkinson (85th minute) for Lang*

We had one group stage game left, against Japan. Japan had beaten Argentina and lost to Germany, just like we had done, and only the top two teams from each group progressed. From the beginning of the tournament we realized this would be the defining moment, and now the time had come to travel to the Boston area to play Japan in Gillette Stadium.

Immediately after we landed in Boston and checked into the hotel, the players held a closed-door (from staff) team meeting to set themselves straight. This was an important task, tackled by Andrea Neil and assisted by Charmaine Hooper. A component of the meeting was a group activity to refocus the direction and energy of the team. The players needed to repair the damage done by the disappointing start, to restore their sense of perspective and to raise individual levels of self-confidence. They would meet, again and again, over the next couple of days. It was a difficult time, mentally and emotionally draining for those involved. But there was no choice. Win, and go to Portland for the quarterfinals. Lose, and go home to Canada and wait another four years for a chance at the World Cup.

The day before the game against Japan, there was a noticeable shift in the energy level of the team. Our training sessions were at Wellesley College, in a beautiful setting. Again, there was great grass on the field, but the backdrop was exceptional with views of a waterway, many trees, and the beauty and serenity of nature. It was a calming environment, which helps when there is so much at stake.

On game day, when we arrived at the stadium, the Norwegians

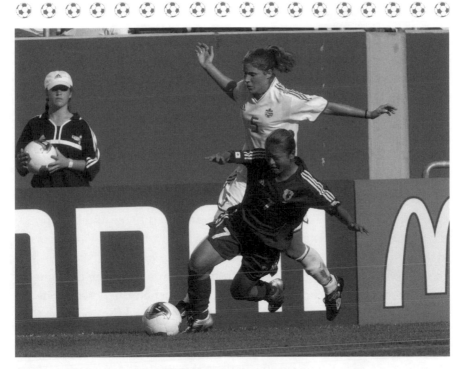

Andrea Neil closely marks a Japanese player.

Christine Sinclair celebrates her game-winning goal by high-fiving Erin McLeod, Randee Hermus and Karina LeBlanc.

were playing South Korea, whom they ended up beating by a large margin to secure a spot in the quarterfinals. It was our turn next. Right from the opening whistle you could see the team was clicking. Even though Japan scored first to take the lead, we were performing up to, and eventually beyond, our potential.

Christine Latham scored to tie the game on a brilliant pass from Christine Sinclair. The game was tied 1–1 at halftime. When we came back onto the field, an early goal was disallowed by the referee when Christine Latham knocked the Japanese goalkeeper into the goal while challenging for the ball. But the team maintained focus and kept pressing to win the game. The second goal came from a Brittany Timko corner kick to the near-post, which Sinclair headed past the goalkeeper – like she has done so many times before from the same spot. The final goal of the game was produced by Kara Lang, who turned the defender at the top of the eighteen-yard box, touched the ball toward the end-line, then crossed it over the Japanese goalkeeper into the back of the net.

We had earned a much-needed reward with a 3–1 victory and, even better, a spot in the quarterfinals of the 2003 FIFA Women's World Cup. We celebrated the victory with a small nucleus of fans, friends and family from Ontario, BC, the Maritimes and even Norway who had made the journey south.

We were off to Portland, and better yet, everyone on the team was confident and performing at their potential.

The World Cup Knockout Stages

Shel Brødsgaard

Flying back and forth across the continent can be difficult, but when you are achieving success it is easy to be highly motivated and deal with adjustments. The coaching staff was lucky to arrive early enough to scout China, our quarterfinal opponent, as their group was concluding group stage games one day later than we did. The Chinese were playing Russia in Portland, Oregon, at PGE Park – the same stadium where we'd be playing them.

The feeling of arriving on the west coast was brilliant – for many on the team there was familiarity in the mountains, trees, clothing, coffee shops and climate. It was like coming home, after twenty-plus days on the road. Travelling back and forth across North America, it is often these little nuances that make a difference. Already, after only three games, it felt like we had endured three lifetimes of stress and tension.

> **Canada versus China**
> **October 2, 2003, Portland, Oregon**
> **Attendance 20,021**
> **Starters:** *Taryn Swiatek, Christine Latham, Andrea Neil, Sharolta Nonen, Isabelle Morneau, Charmaine Hooper (captain), Christine Sinclair, Diana Matheson, Kara Lang, Brittany Timko, Tanya Dennis*
> **Substitutes:** *Silvana Burtini (12th minute) for Morneau, Rhian Wilkinson (73rd minute) for Latham, Kristina Kiss (90th minute) for Lang*

The quarterfinal game against China would be the biggest event in Canadian women's soccer history. China was known as one of the

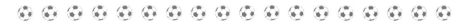

top teams in the world, having finished second at the last World Cup, and few if any expected Canada to win. The atmosphere in PGE Stadium was electric – the city of Portland was invaded by Canadians who had travelled down the I-5 highway. It was like a homecoming for our team. There were so many Canadian flags that the colours of red and white completely dominated the crowd – except for one group of well-orchestrated Chinese fans, in full costume, who were weaving in and out of the crowd with a forty-foot dragon and chanting in unison.

The most important goal ever scored by Charmaine Hooper came in the eighth minute, from a long pass played by Diana Matheson in behind the Chinese defenders. The time it took for the ball to travel from the left foot of Matheson onto the head of Hooper felt like slow motion. Watching the ball go by the approaching goalkeeper into the net was incredible. The entire bench cleared, and we were all screaming, waving and hugging each other. We took the one-goal lead and defended the remainder of the game.

Shortly after the Hooper goal, however, defender Isabelle Morneau rolled over on her knee while sliding to tackle a Chinese player

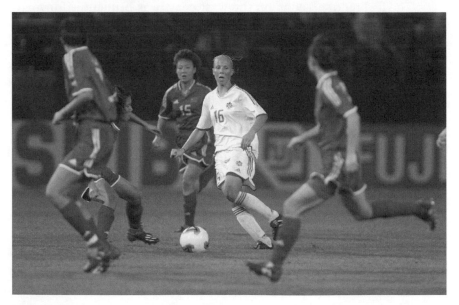

Brittany Timko releases pressure by looking to pass as four Chinese players attempt to close her down.

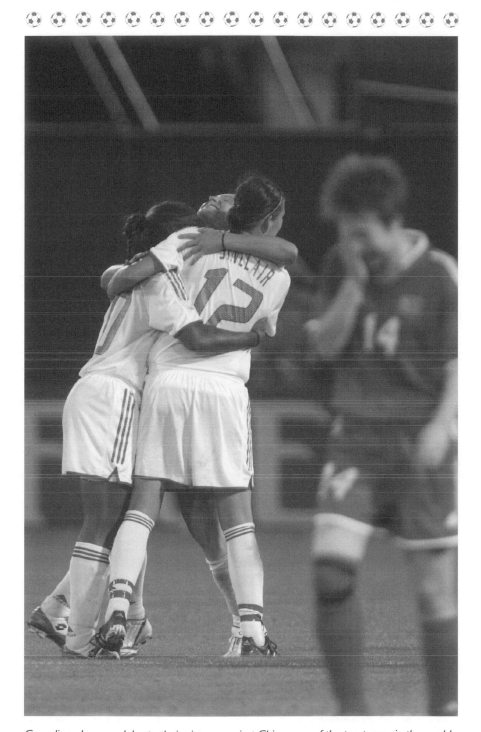

Canadian players celebrate their victory against China, one of the top teams in the world.

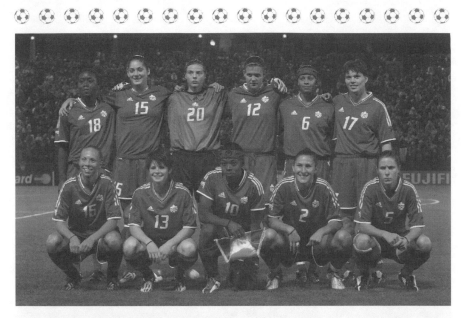

Anticipation rises: the team prepares for its game against Sweden.

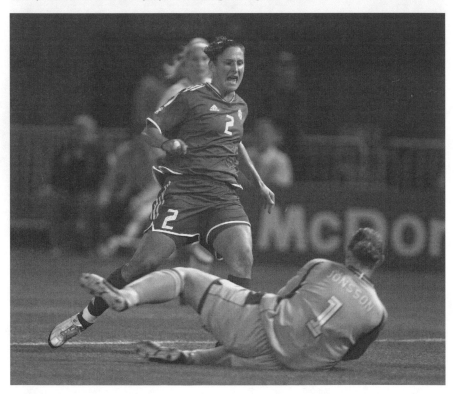

Christine Latham battles a Swedish player in this high-pressure game.

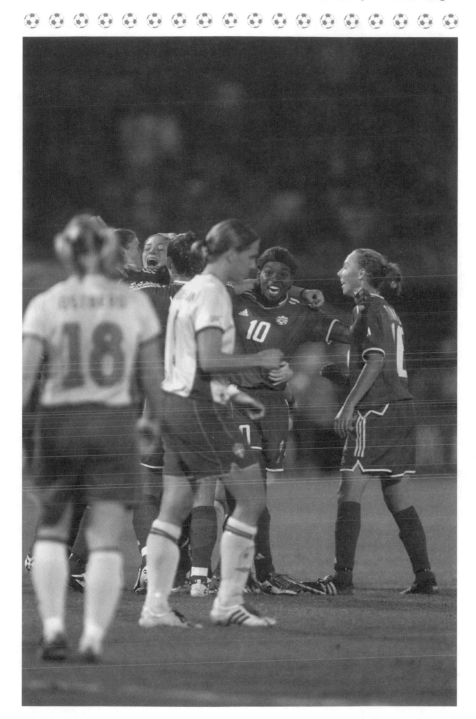

Goal! Charmaine Hooper celebrates Kara Lang's goal with her teammates in the game against Sweden. The Women's World Cup final is 25 minutes away.

on the edge of our penalty box. Morneau was injured and replaced by veteran Silvana Burtini, a native of Williams Lake, BC, who was playing in her seventy-seventh international game. Burtini usually played forward, and once scored an incredible eight goals in the first half of a game against Puerto Rico.

The Chinese were a much more talented team on a technical level, controlling the ball and speed of play. But they never charged directly to the goal. They simply could not and would not score, thanks to the defensive pressure from the whole Canadian team combined with the outstanding play of Taryn Swiatek. It was like time stood still: sitting on the bench, every five minutes that passed seemed like an hour. The tension was unbelievable. When the final whistle blew, the players on the field locked arms, the subs cleared the bench. The sense of relief and accomplishment was overwhelming.

Swiatek had played the game of her life, one that would serve as the template for all aspiring goalkeepers in the female national team program. She was quick to make decisions and aggressive coming off her line, closing down some of the best players in the world one-versus-one. She was also difficult to beat in the air: any ball crossed into the box within her reach was taken with confidence and cleanly caught. Her timing and consistency were critical to the entire performance, and she acted quickly, efficiently and confidently. Her humble reward after turning in this performance was to retreat to the comfort of our team hotel to enjoy a hot chocolate.

I remember entering the stadium partway through the semifinal game before ours, Germany and the USA. The American team was losing. Unable to control my nerves, I had to escape to the change room rather than watch the remainder of the game unfold. All I could hear were the roars from the crowd, hoping for some American goals to gain the USA another entrance into a World Cup final, but the game ended 3–1 for Germany. The stage was set for our semifinal match against Sweden, and as we took the field for the pre-game warm-up I remember a friendly American fan screaming from the stands directly behind the goal, "Go Canada! You are all we have left!"

> ## Canada versus Sweden
> ## October 5, 2003, Portland, Oregon
> ## Attendance 27,623
>
> **Starters:** *Taryn Swiatek, Christine Latham, Andrea Neil, Sharolta Nonen, Silvana Burtini, Charmaine Hooper (captain), Christine Sinclair, Diana Matheson, Kara Lang, Brittany Timko, Tanya Dennis*
> **Substitutes:** *Kristina Kiss (55th minute) for Burtini, Rhian Wilkinson (74th minute) for Latham*

Sweden, whose world ranking was fifth prior to the tournament, came into the contest with several dominating players: the two strikers Hanna Ljungberg and Victoria Svensson along with attacking midfielder Malin Moström were a threat on the fast break and counterattack. It was going to take everything we had to defeat them – which was to be expected at this stage of the tournament.

After a scoreless first half, Kara Lang scored on a direct free kick from thirty-three metres out in the sixty-fourth minute – a rocket that went right through the hands of Swedish goalkeeper Caroline Joensson. Once again we were leading 1–0, and this time there was only twenty-six minutes remaining on the game clock. It was a matter of holding on, similar to the game against China. But the Swedish pressure was relentless. They tied the game in the seventy-ninth minute, taking advantage of a fast free kick, and completed the scoring with a second goal in the eighty-sixth minute. Our run for the World Cup final was over. The wind was taken out of our sails. We were so close to reaching the final. And now, for the first time in three weeks, we had some time to rest before preparing for our third-place game against the Americans.

I remember sitting across from Even Pellerud earlier in the summer when he handed me the *Globe and Mail* sports section. One of the headlines stated that the CBC had turned away from televising the 2003 Women's World Cup because it felt there would be little interest. It was later reported that the second-largest viewing audience ever for a CTV Sportsnet broadcast had taken place on this very night, with 600,000-plus fans viewing the game back home in Canada.

Canada versus USA
Carson, California, October 11, 2003
Attendance 25,253

Starters: *Taryn Swiatek, Christine Latham, Andrea Neil, Sasha Andrews, Sharolta Nonen, Kristina Kiss, Charmaine Hooper (captain), Christine Sinclair, Diana Matheson, Kara Lang, Brittany Timko*

Substitutes: *Isabelle Morneau (84th minute) for Andrews, Rhian Wilkinson (89th minute) for Lang, Carmelina Moscato (90th minute) for Neil*

The team flew out the next day to Carson, California, to prepare for the consolation final. Thankfully, we had a week to recover, and needed and deserved the break. Getting fired up to play the USA is an honour and a privilege, but we needed some space and time to do other things. Several daytrips were planned to Disneyland, to Redondo Beach, and to the shopping mall. In the consolation final against the Americans, we played in the Home Depot Center, which was the newest soccer facility built in the United States. Home to the LA Galaxy from the MLS, it was a modern soccer-specific stadium.

The intensity of this game for third place was extremely high; there seemed a lot more at stake than receiving a medal. In the first few

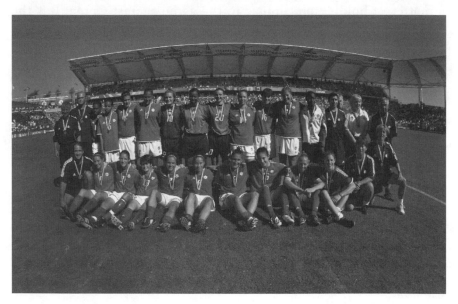

The team poses for a photo after the World Cup awards ceremony.

minutes of the game, shortly after the kick-off, the crowd of more than 25,000 were chanting "USA! USA!" It was almost deafening. Luckily, it stopped shortly after it started, but what an intimidating environment to play in.

It was another close game that could have gone either way. American veteran Kristine Lilly scored midway through the first half. Shortly after, one of Kara Lang's shots hit the post, while another drive forced American goalkeeper Brianna Scurry into making a diving save. Finally the pressure paid off when we scored a goal near the end of the first half from a classic Canadian attack pattern. In this case, one long pass was sent to striker Christine Latham, who turned and played a ball into Sinclair, who then beat the backline with a well-timed run. Like I have said many times before, witnessing Sinclair one-versus-one with the goalkeeper is a brilliant feeling.

There were several nasty tackles in the game, one involving Brittany Timko and Americans Cindy Parlow and Abby Wambach, with Parlow suffering a concussion. Charmaine Hooper collided with Abby Wambach right in the centre of the field, emitting a loud thud heard throughout the stadium. Unfortunately, the Americans scored two second-half goals and we lost 3–1.

Reality had set in, but we knew that we had a young team that could take these painful lessons and come back stronger. With many of the star American players nearing the end of their careers, we knew we would have to wait patiently for our opportunity. It was hard to accept defeat, but we were the fourth-best team in the world, with a tremendously bright future!

Profile

Taryn Swiatek

Bob Mackin

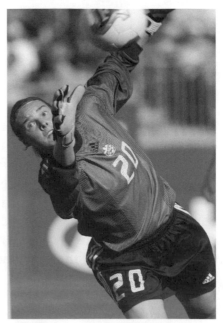

After taking a year off due to an injury, Taryn Swiatek became the starting goalkeeper for most of the World Cup tournament.

Taryn Swiatek gave up hockey to play soccer. It's a sacrifice that she'll never regret.

She began playing hockey at age six, but stopped because she was the only girl on the ice. Ironically, she eventually found herself playing soccer on a boys team because there weren't enough strong girls teams in her birthplace of Calgary.

"The fact that I was playing with boys helped me develop a bit of an inner strength," said Swiatek.

Swiatek played both soccer and basketball in high school. When it came time to devote herself full-time to soccer she missed her graduation because she was playing in the 1999 Pan Am Games held in Winnipeg. She also played from 1999 to 2001 with the University of Calgary Dinos while studying geography.

During a national team training camp, Swiatek caught the eye of the W-League club the Ottawa Fury, who signed her to a contract. A knee injury, though, kept her away from both the Fury and the national

team for 2002. That also meant missing the CONCACAF Gold Cup tournament, which doubled as the qualifier for the 2003 Women's World Cup.

"I considered how much soccer is a part of my life, how much I missed it, how much I wanted to play again," she said. "Being out for a year gave me a new perspective; it really cleared my mind and refreshed me."

In 2003, she resumed play with Ottawa and returned to the national team pool. Swiatek had benefited from the amount of mental preparation she had done, which included reading numerous motivational books. She didn't feel a pressure to succeed – she just wanted to do her best and it eventually paid off.

"A couple of years ago I would never have believed I'd be a starting goalkeeper in a World Cup game. It took awhile, but I began to believe in myself. The only limitations are the ones I put on myself."

As the tournament drew closer, she was preparing to play a supporting role to starting goalkeeper Karina LeBlanc and backup Erin McLeod, another Calgarian. "And then the tournament came and everything changed."

The situation shifted so radically overnight – after the opening loss to Germany – that Swiatek can't remember exactly where or when it was that coach Even Pellerud told her she would start against Argentina. The whole tournament was a blur, even the 1–0 quarterfinal shutout of China that vaulted Canada into the final four.

"Our whole team worked hard the whole ninety minutes. We hardly gave them an inch. Their team, they're not very aggressive. If you go into a tackle they will jump over you, they won't stick in there. That was also a key to our win."

There were two things she did remember about that night: the roar of the crowd after Charmaine Hooper's goal and the roar of the crowd after the final whistle.

"Those were two of the most unbelievable feelings I've had. I don't think I'll ever forget that."

She was able to win three important games in a row (and register two shutouts) due to the intense mental and physical preparation she had done through the summer leading up to the World Cup. She

didn't think she would start, but she prepared herself to be ready at a moment's notice.

"I had never been in a big tournament before, so this was it, this is what everybody works for. I thought, 'there's nothing to lose.' There's no reason to save energy or to be afraid."

Although she felt pressure to keep the ball out of the net, she also felt pressure to set a confident tone for the rest of her team to follow.

"If you're confident at the back, then it permeates throughout the back four. The way they go in for tackles sets the tone for the midfield, and so on."

Perhaps the biggest challenge Swiatek faced was overcoming her reserved nature to become the most vocal player on the field. Communication with teammates and alerting them to things they may not notice is a vital skill for all goalkeepers. So is thinking about present and future balls instead of those in the past. Or those that went past.

"The important thing is to keep perspective – it's just a goal, it's just a game. It doesn't matter. You need to be detached from it, because in reality in a game, if you're thinking about something that happened, you're not thinking about what you're doing now. Revisit it after the game, of course, to see how it can be prevented in the future, but at the time, totally forget about it."

Though she's forging her own style, Swiatek doesn't have any superstitions that set her apart. Beyond her natural shyness, she considers herself a technician in net, an extension of the back four. "Calculated" and "precise" are two words she says fit her the best.

One of the most important things she learned over the years was to respect coaches and referees.

"Respecting your coach and the referee is basically respecting the game. If there's a bad call, I don't believe there's any place for a dispute. You're wasting your energy on something you have no control over. I like to project an aura of respect and hopefully I can influence my teammates with that same attitude."

Isabelle Morneau

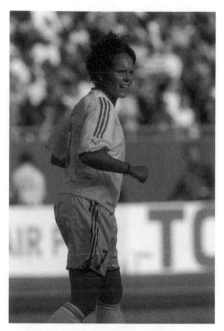

Isabelle Morneau is a veteran midfielder who came back from injury to help out on defence during the 2003 Women's World Cup. She has played in three World Cup finals for Canada.

Bob Mackin

For Isabelle Morneau, soccer was a family affair. She started playing when she was five with her older brother and older sister on the South Shore of Montreal.

"I pretty much grew up on the soccer field," Morneau says. "I've always been interested in soccer. As soon as I could get in and join a team I played, and since then I never could stop."

Because of the sport's popularity in Quebec, she had the luxury of playing on girls teams. That, however, was where the luxury ended.

"Obviously Quebec hasn't got the best weather in Canada, so we can't train outside all the time," she says. "We try as long as we can, but it gets so cold and then we get more injuries. It's great for us to be able to train indoors."

She stayed with soccer while older sister Marie-Josée took her kicking to the sport of judo. Still, the sisters remain close confidantes.

"She's been my mentor," Morneau says of Marie-Josée, who represented Canada in the Olympics. "I like the way she handles train-

ing and the whole mental aspect of handling stress. I've had a long history of injuries. She's always been the first person I've called."

Isabelle has followed Marie-Josée's lead in the way she approaches her sport and education. Like her sister, Isabelle is pursuing a career in physiotherapy.

Morneau has played for the Montreal Xtreme and the Ottawa Fury in the W-League. She made her national team debut against France in a 1–0 loss on April 11, 1995, and scored her first goal two years later on June 4, 1997, in a 2–1 loss to Italy in the US Cup. She studied and played at the University of Nebraska, where she earned a degree in psychology. Born April 18, 1976 in Greenfield Park, Quebec, she now lives in Longueuil.

Morneau nearly had to miss the 2003 Women's World Cup because of a serious shoulder injury that required surgery. She went home after the tournament with ligament damage in her knee, but she says it was worth it.

"You get injured and the first thing that comes to mind is the rehabilitation and the pain, and am I going to be a good player again? Am I going to fill my shoes out as I did before?

"I'm excited about playing at this level and playing with my teammates who are almost my sisters, we spend so much time together. It's all these little things that help you overcome an injury. When you're in physio by yourself, you just have to get up and go."

When she got the call to join the team during the summer of 2003, she was thrilled. She was further elated when she came on to play against Japan as a substitute after missing the first two games of group play against Germany and Argentina.

"I was so ready I was on fire. I gave everything I had and I did pretty good during that game. It's really unfortunate that the next game I had an injury again."

That next game was against China. She was on field to see the only goal scored, but had to watch for more than a half from the sidelines as another veteran, Silvana Burtini, went in to play her position after Morneau's leg got caught in the temporary natural grass surface and twisted her knee.

At halftime her leg was iced and she changed into her training suit.

On the way back to the bench to watch the second half, she thought that might have been the end of her career.

"I had in my head: 'I've had enough, where is it going to end?' It was pretty painful and hard to deal with it again."

But Morneau wasn't done for the tournament. Adrenalin propelled her and she played in the bronze medal match against the United States in Los Angeles.

"First, I'm a player, and second, I'm a physio. As a physio I don't think I should've come back for the US game, because I did more damage to my knee. But the player overcame the physio side. If it wasn't the World Cup, if it was just an ordinary game, I would've let it go. But I worked so hard to get there and I had to give it a shot."

Morneau got her start training with the national centre when Sylvie Béliveau was coach. Morneau was chosen to play for the national team in 1995 and she's been part of the player pool ever since – even during her time studying at the University of Nebraska.

"Sacrifices, that's what it's all about. That's what soccer at this level is. You sacrifice not seeing your family, your boyfriend, your friends . . . it's hard on relationships. It's fun, it's a lot of fun, but it's a sacrifice. When you come back it's like rush, rush, rush.

"School-wise, you have to be organized and have good friends at school who help you out with notes, or call and say you need to do this or that. But at the end it's so worth it, I just wish it for everybody."

End of the Cup, But Not the End of the World

Shel Brødsgaard

It was a privilege to return home and speak with family and friends who watched the tournament. There was tremendous support for the team. The phone began to ring off the hook with special requests for player appearances at media-related events, guest appearances at coaching seminars and/or awards for the team and head coach.

Some critics still call our playing style "kick and run." The same voices question the longevity of the team's success, claiming that "the game will pass us by." Regardless of how successful you are, there will always be people trying to knock you down. This is part of being on the top, I guess. We choose to listen to the positive remarks, focus on our game plan, consider suggestions and disregard the negative.

After an event like the World Cup is over, the transition for each of us is unique. Coming down from that high has not been easy. Some players went directly into their college seasons. Others relaxed for the first time all year. The conditions vary, but the feeling is the same. What an amazing accomplishment – fourth place at the Women's World Cup – which presents a whole new set of complications: the bar has definitely been raised. Individual and team performances are expected to be much higher. The pressure is on the team and individuals to perform, and perform well.

Qualifying Games for the 2004 Olympics

Unfortunately, in our first major test following the World Cup, we failed to qualify for the Olympic Summer Games in Greece. In Costa Rica,

Reeling from an Olympic Fall
—Elaine Sun, March 5, 2004

The final score says it all: Canada 1–Mexico 2. We are not going to the 2004 Olympic Games and I'm reeling. Many Canadians have been trying to pinpoint the team's problems, but nothing will change what took place during the game, nor make it easier to deal with. Being that I am a die-hard Team Canada supporter, I can only approach this event from my perspective as a fan.

I want to focus on the people most affected: the players themselves. I have so much respect and admiration for them, and have followed their careers from the time they toiled in anonymity to all their successes the last few years. My heart breaks for the core group of veterans for whom the 2004 Olympics was the last big tournament before they retire from the national side and move on with their lives. Players such as Charmaine Hooper, Andrea Neil and Isabelle Morneau are most likely seeing their careers cut short. These are women who have been through it all—the good and the bad—with this program, and have truly shown their dedication and commitment in representing their country in a game they are gifted at and love to play. The Olympics was the last thing on their list they had yet to experience, and 2004 was the time and place to check that off.

The Olympics is a huge reason why many players have trained tirelessly over the years. To represent their country at the international stage with other top athletes is a tremendous accomplishment, as is simply being called an Olympian. Any top-notch athlete strives for this. But there will be other Olympics in the future. We have an amazingly talented team with many young players who will continue to go all-out to reach that destination.

In conclusion, I will share a personal story that exemplifies how I feel. My favourite player on Team Canada since the very beginning has been Isabelle Morneau. Izzy experienced a serious shoulder injury last spring that required her to have surgery and miss most of Team Canada's preparations for the 2003 Women's World Cup. In July, I attended Canada's two games against Brazil in Ottawa and Montreal. At both games large crowds of passionate fans cheered and the buzz in the stadium was contagious.

As I stood on the field after the Montreal game, I spoke to Izzy. She was in awe of the amazing atmosphere in her hometown and how much the support for the team has grown since she first joined in 1995. I asked her how she felt being unable to play. She gestured towards the stands and said it was always her dream to take to the field in front of a large crowd filled with her family, friends and people who have supported her through the years. I told her she would get that chance the next year, when the team would return to Montreal in preparation for the Olympics. She smiled wistfully and said she hoped so.

With her Olympic dreams now dashed, will Izzy get her dream fulfilled? Will she get to play in front of a large hometown crowd before she hangs up her cleats

> *for good to focus on her career as a physiotherapist? This is why the loss to Mexico has been so difficult. It's not just about the soccer; it's about the players. So please, take a good look at your current Team Canada. This could be the last time you'll see this team intact. It is a team we've all grown to love and it will continue to need your support for future challenges.*
>
> *Elaine Sun published an earlier version of this article at her Canadian women's soccer fansite www.gobigred.ca.*

after beating Jamaica, Panama and Costa Rica in group stage games, we lost to Mexico 2–1 in the all-important semifinal. A win would have reserved us a spot in Athens.

It was a team we had beaten ten times before, which certainly came as no consolation. All I could feel was emptiness; for the first time in three and a half years, the program had been set back. A flood of emotion unravelled when each of us realized how much this was going to change our lives, both in the short and long term.

Even though there is phenomenal growth in girls' soccer through-out North America, the whole face of women's soccer at the highest level is changing. There is no WUSA to fall back on, and the league is currently awaiting some sort of possible rebirth. As well, there are lim-ited resources available from the Canadian Soccer Association to con-tinue developing the national team. In fact, the first topic of discussion among the staff was regarding the transfer of all available finances to the Under-19 team, which was facing qualification for the 2004 Under-19 FIFA Women's World Championships.

This was the end of an era, from the 2002 U-19 World Champion-ships through the 2003 Women's World Cup. Many of the stars of that U-19 team, including Christine Sinclair, Erin McLeod and Sasha An-drews are now too old for the U-19 team. The next major event for this age group and the senior national team is the World Cup in 2007, to be held in China, followed by the 2008 Summer Olympics, also in China. Qualification for both of these events will start early in 2006.

The National Team in Closing

The senior team assembled in Nashville, Tennessee to play the USA on July 3, 2004. It was our first game since being knocked out of the

Olympics; meanwhile, the Americans were in the final stages of their preparations for Athens, a tournament they would ultimately win. Due to limited funding, we were only able to train twice prior to the game. There was new energy around the team, which was a mix of young and experienced players: the likes of Charmaine Hooper, Andrea Neil, Taryn Swiatek, Christine Sinclair, Diana Matheson, Brittany Timko, Kara Lang, Aysha Jamani and Emily Zurrer.

This game would serve as our first event on a new cycle, one that will see us through the 2007 FIFA Women's World Cup, as well as the 2008 Olympics, both being held in China. It was a great game, with goal-scoring chances both ways. The USA sneaked away with a 1–0 victory. But the energy surrounding the team was exciting, and provided hope and promise for us all to work towards and achieve an even better showing on the international stage in years to come.

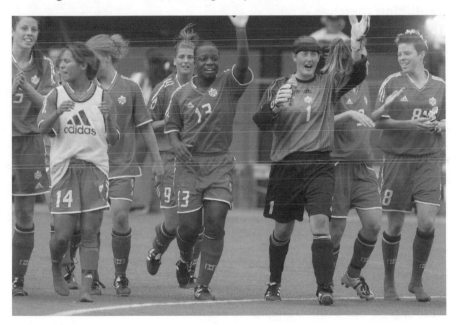

United: The Canadian women's soccer team looks forward to the future of the game.

The 2004 FIFA U-19
Women's World Championship

Shel Brødsgaard

Exhibition Matches

The team travelled to Montreal and Ottawa in the first two weeks of May to play exhibition matches against Germany. This gave us an opportunity to face a top-flight opponent and adjust to being on the road again.

The two exhibition games were extremely competitive. In the first game, played at the Lachine Soccer Centre in Montreal, 2,100 fans were treated to a 3–0 Canadian victory, with two goals scored by Aysha Jamani, one by Selenia Iachelli, and the shutout by Stacey VanBoxmeer. The second game of the series, in front of 2,200 at Keith Harris Stadium in Ottawa, was taken by the Germans 1–0. It was a great test for our team to match up against one of the best sides in their age category.

The Qualification Tournament

The qualifying tournament to get to the World Championships was held in Canada, with games in both Montreal and Ottawa. In total there were two groups with four teams in each:

> **Group One:** USA, Costa Rica, Trinidad and Tobago, Dominican Republic
> **Group Two:** Canada, Mexico, Panama, Jamaica

The tournament was a group stage format, with each team playing

against the other teams in its group. The top two would then cross over in a playoff format similar to the 2002 Gold Cup. This time the Mexicans were in our pool, which meant our group stage game against them would probably decide whom we would play in the semifinal.

In our first game, played on FieldTurf at McGill Stadium in Montreal, we beat Jamaica 4–0 on two goals from Jamani, one from Lang, and one from Josee Belanger. Back at Frank Clair Stadium, also on FieldTurf, Canada scored seven goals en route to an easy victory over Panama: Jamani with another two, and singles by Lang, Belanger, Timko, Jodi-Ann Robinson and Amanda Cicchini. VanBoxmeer recorded her second shutout.

Game three was played against Mexico, whom we had earlier estimated to be our most difficult opponent in group stage action. Played in Ottawa, it was a game dominated by the home team from the start, with the final score 3–0 Canada. Goals were scored by Belanger and Emily Zurrer, who made two second-half tallies in a span of three minutes to seal the deal. This victory placed us in the semifinal against Costa Rica, with the winner advancing to the FIFA U-19 Women's World Championships in Thailand. In front of 2,354 spectators, Canada defeated

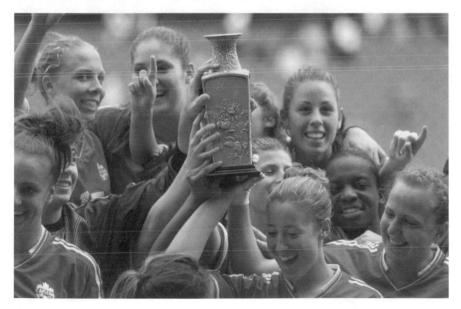

Canada celebrates its U-19 team victory over the US in the World Championship qualifying tournament.

Costa Rica 4–0. Stacey VanBoxmeer earned her fourth straight shutout, supported by a Costa Rican own-goal and successful shots by Zurrer, Timko and Véronique Maranda.

The final game against the USA was to identify the number-one seed from the CONCACAF Region for the FIFA U-19 Women's World Cup draw. We were up against our nemesis from the south, but this time more than three thousand fans in Ottawa would see us walk away as champions! Aysha Jamani put us into the lead after only three minutes, but the Americans tied it just before halftime. It was an extremely close game, tied 1–1 at the end of regulation play, that was decided in golden-goal overtime. Josee Belanger headed home the winner off a Kara Lang free kick in the 118th minute.

In addition to the championship trophy, two Canadians were given awards at the closing ceremonies: VanBoxmeer was named top goalkeeper of the tournament and Zurrer was the tournament MVP. The celebrations that followed were well-deserved. The team enjoyed a victory meal together with close friends and family at a Thai restaurant in downtown Ottawa.

Profile

Aysha Jamani

Bob Mackin

Aysha Jamani of Calgary emerged as a goal-scoring force in 2004.

F rom the day Aysha Jamani could walk she wanted to be involved in every possible activity, so her parents tried her out in all the sports available in her hometown of Calgary.

"When I was about eight years old, my dad signed my sister and me up for soccer," Jamani says. "Ever since my very first little-league game, I fell in love with it. My dad has always been a fan of soccer. He loves to watch it on TV whenever he can so I think his passion for the game rubbed off on me."

From her club team in Calgary, she made the U-12 Calgary Selects team at age eleven, and travelled to tournaments as far away as San Diego. After another successful summer with the city's U-13 Selects, she was invited to join the U-14 Alberta Provincial Team. At its first big tournament, in Seattle, she helped the team capture the silver medal. Aysha was quickly establishing herself as a winner, also taking her club team to the provincial championship and a national bronze medal that year.

It was a few months after another bronze, this time for the provincial U-15 team at the All-Star Nationals in Quebec, that she was invited

to the National Training Centre in Calgary, and then her first U-16/U-17 national team camp.

In November 2003, at the age of sixteen, she attended her most memorable camp so far: her first with the Women's U-19 team, held in Vancouver. Her initial taste of international competition came in January 2004 with two games against Trinidad and Tobago. Only one week later, Jamani continued her meteoric rise by earning an invite to play for Canada's senior side at the Four Nations Cup in China. She collected her first three caps at the tournament, her first experience of playing against and alongside some of the top names in women's soccer. The next month she scored her first international goal with the senior side at Olympic qualifications in Costa Rica.

Jamani credits much of her success to a "backbone" of strong and constant support from family and friends. Since that first little-league appearance, her parents have driven her "everywhere," bought her equipment, attended all her games, and made sure she was playing for the local clubs she wanted.

"I know that I could not be where I am today without everything they have sacrificed. My parents have given up so much of their lives to concentrate on mine."

Jamani is also grateful for the invigorating encouragement of friends.

"When I'm away from home all it takes is e-mail from a friend and I'm in such high spirits. They are my number-one fans and take interest in watching me play because they see how happy I am doing something I love. They have believed in me when I didn't even believe in myself, which is the best support I could ask for."

When Jamani isn't playing soccer, or catching up on her high school studies, she can usually be found obsessively following the sport.

"I love reading about it, watching it and of course playing it. The more I watch some of the best players in the world on TV, the more I learn and the more motivated I become. I remember during the men's World Cup in 2002, I would wake up at 3 am to watch every single game of the tournament. I had never been more tired during that month and have never gotten in so much trouble for falling asleep in class either. I would love to get the chance to meet some of my favourite players such as Zinedine Zidane or Thierry Henry."

At this stage of her career, Aysha's toughest challenge has been to balance her busy soccer schedule with her studies. She finds herself with only brief windows during the year when she can concentrate on school, because she often cannot when soccer is in full swing.

"I try my best to manage my time so that I can focus on soccer when it is important and I can focus on school when it is important."

In fall 2005 she will move her studies and her game to the University of Nebraska. Jamani looks forward to a long future with the senior national team, hopefully with appearances in the Women's World Cup and the Olympics. And hopefully with time to take in her surroundings as she competes internationally:

"I'm interested in fashion and world history, I'd love to someday just travel and learn about different cultures and lifestyles around the world. I think that would be an incredible experience."

Getting Ready to Defend Silver

Shel Brødsgaard

The FIFA U-19 World Cup draw was held on June 11, 2004, in Bangkok, Thailand to determine the schedule for the tournament. This draw ultimately produced three groups of four teams for the tournament.

> **Group A:** Canada, Thailand, Australia, Germany
> **Group B:** Nigeria, China, Italy, Brazil
> **Group C:** South Korea, USA, Russia, Spain

The draw worked out in our favour; we knew we were very capable of competing with Germany for the top seed coming out of the group stage. But first, playing against Australia would be the number-one priority. It's essential to start the tournament off with a favourable result, and we needed a victory to keep pace with the Germans' first matching of Thailand. Some of the pre-tournament favourites included Brazil, with their stars Marta and Cristiane; Germany with Anja Mittag; the Americans with Angela Woznuk; and Canada with Kara Lang and Brittany Timko.

During the summer, in the months leading up to the tournament, games were scheduled for the World Cup team against the USA and Japan. This served as an opportunity for the youth team players to mix with senior players and gain experience at the international level. In July in Nashville, Emily Zurrer, Kara Lang, Brittany Timko, Aysha Jamani and Véronique Maranda were called up to join veterans like Charmaine

Hooper, Andrea Neil, Taryn Swiatek and Christine Sinclair on the World Cup team.

In a very short period of time, from the Olympic non-qualification in March earlier that year, you could see that the face of the senior team was changing.

Twelve U-19 players were also selected for a two-game series against Japan in Tokyo: VanBoxmeer, Timko, Belanger, Zurrer, Cicchini, Jamani, Lang, Robinson, Maranda, Stephanie Labbe, Sari Raber and Katie Thorlakson. On July 30, the Canadian Women's World Cup Team was defeated 3–0 by Japan in front of 27,600 spectators at Tokyo's National Stadium. The second game saw Canada triumph 2–1 on goals from Timko and Jamani.

Immediately after the return of the team, the Vancouver Whitecaps were crowned W-League champions. The team featured ten members of the national program: Neil, Lang, Timko, Thorlakson, Erin McLeod, Sasha Andrews, Clare Rustad, Randee Hermus, Carmelina Moscato and Amber Allen. Shortly after the W-League season ended, the majority of the U-19 team reassembled in Vancouver on August 28 to begin preparations for the Thailand tournament, where it trained daily at Simon Fraser University. Six players were with their American college teams – Tanya Dennis, Sari Raber and Brittany Timko (Nebraska), Katie Thorlakson (Notre Dame), Stacey VanBoxmeer (Indiana) and Caroline Vanderpool (Louisiana State) – and couldn't participate in the camp.

While training, the team played numerous exhibition matches with boys select teams and senior women's teams in the Vancouver area, on Vancouver Island and in Seattle. The players also had a two-night team-building camping trip to Denman Island where they cooked together, lifted logs and made an appearance at a community school. On a further visit to Alert Bay the team was welcomed by the community of 1,500 with traditional native dancing and food. The next morning, they held a soccer clinic for 150 kids and tied the Alert Bay Selects, a U-20 men's team, 1–1. As well, in early October, the players took part in the CIBC Run for the Cure, which helped raise money for breast cancer education and research.

An unexpected news release came from FIFA on October 6: *From 2006 onwards, the FIFA U-19 Women's World Championships will be staged as a U-20 world championship.* With these changes to the age

category, we will lose only four players from the current roster of twenty-one for the next world championships in 2006. Kara Lang could potentially play in three Youth World Cups, and a host of others will also see a second competition. Of course, this means players such as Marta from Brazil will also return, but what an amazing opportunity for our country to win a World Cup!

Brittany Timko

Bob Mackin

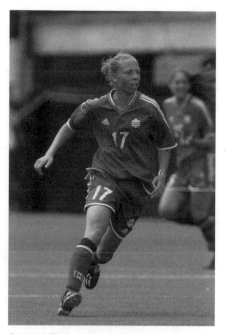

Brittany Timko was named to the FIFA All-Star Team at the U-19 World Championships in Thailand and was winner of the Golden Boot Award for being the top goal scorer. Timko had seven goals in four games.

At the 2004 U-19 World Championship in Thailand, nineteen-year-old Brittany Timko emerged as a major international star for Canada, picking up all-star team honours and the Golden Boot award as top goal-scorer in the tournament – with seven goals in four games.

A product of Coquitlam and Burnaby soccer programs, Timko started representing BC at the U-14 level, helped the province win the bronze medal at her U-15 nationals, and suited up for Canada for the first time at the U-16 level. Later that year, she attended her first camp with the senior World Cup team, earning her first cap against Japan.

Timko credits her parents, brothers and coaches as being instrumental in her soccer success. Her current coach at the University of Nebraska, John Walker, has had a significant impact on her development.

"He wants to help you develop into a good person first, and a soccer

player second," Timko says of Walker. "He is extremely knowledgeable, and has a passion for the game that is evident in practices and games."

Walker also played a hand in tapping into Timko's goal-scoring touch as a striker, a position she had played in youth soccer but had later been switched for midfielder on the U-19 and World Cup teams.

"John gave me the freedom to be creative and try new things, and it was a lot of fun to be able to contribute to a team more than I had before. Being at Nebraska also helped a lot with my confidence in being a striker. I worked a lot at Nebraska on finishing around the net and different techniques to use while shooting. Before, I would shoot the ball and just be happy to get it on net. Now when I shoot, I shoot to score and anything less is not acceptable to me.

"Confidence is the biggest aspect of performing at the highest level. Without confidence, it is hard to play at the same level as the rest of the players on the field. The greatest players in the game all have a certain confidence in themselves. They believe in their abilities, and love having a challenge ahead of them."

With Timko's new outlook, it was natural for her to take on the striker position in Thailand, and find so much success with it. She emphasizes, however, that having the sniper's role of blasting balls past goaltenders is no more important than any other position on a team:

"Leading the tournament in scoring was pretty neat, but it was my teammates who did all the hard work and made it easy for me. There are so many different things that need to happen on a soccer field before the ball reaches the net, and from our goalie right up to the other forwards, everybody was playing hard, which made scoring goals a lot easier."

Brittany has a great appreciation for the talents and personalities of teammates such as Christine Sinclair and Katie Thorlakson.

"I don't think I've ever seen a player before who is such a natural finisher as Christine. Every time she touches the ball around the net something special happens, especially in clutch situations."

Timko's relationship with Thorlakson is a great example of the bond that can develop between girls growing up and playing a sport at the highest levels together.

"Katie has been one of my really good friends since we first met on the U-14 provincial team. We started hanging out a lot, and we've played together since. We actually used to play against each other with

club soccer, which was kind of funny sometimes, but for the most part we have played on the same team: all the provincial teams, the U-16 to U-19 national teams and now the World Cup team. It's so much fun to be playing with a close friend, and I'm really glad I get to do that with Katie."

Brittany has sage advice for other girls and young women pursuing the sport of soccer:

"Enjoy the game. As soon as you stop enjoying something, you usually don't do as well. You should welcome any pressure as a new challenge and don't put too many expectations on yourself. Just have fun, learn to love the pressure, and you'll excel under any circumstances."

Tournament Time in Thailand

Shel Brødsgaard

The final U-19 World Women's Championship roster was selected on October 22 and the team travelled to Thailand on November 2 to adjust to the time change – fourteen hours ahead of Canada's west coast – and hot, humid tropical climate. Two exhibition games were arranged against Russia in Karon Stadium in Phuket, a city which would be devastated by a tsunami less than two months later. This was a good pre-tournament test, plus allowed the team to enjoy time in a fabulous beach resort area following the two-month residential camp in Burnaby. Immediately after each exhibition game the team walked across the road from the stadium to swim in the Indian Ocean.

In the first game, on November 4, we defeated Russia 2–0. Goals

Final 2004 U-19 World Championship Roster

Stacey VanBoxmeer	Selenia Iacchelli
Stephanie Labbe	Josee Belanger
Erin McNulty	Kate Bazos
Katie Radchuck	Deana Everrett
Robin Gayle	Aysha Jamani
Tanya Dennis	Kara Lang
Emily Zurrer	Sophie Schmidt
Justine Labrecque	Brittany Timko
Amanda Cicchini	Sydney Leroux
Véronique Maranda	Sari Raber
Jodi-Ann Robinson	

were scored by Aysha Jamani and Deana Everrett, who also received her first U-19 team cap. Goalkeeper Stacey VanBoxmeer earned the shut-out. Two days later the team won the second game of the series 2–1, with goals from Jamani and Jodi-Ann Robinson.

Unfortunately, Emily Zurrer received sixteen stitches in the centre of her forehead from a collision while trying to head the ball. Véronique Maranda suffered a concussion, keeping her from training and poten-tially from the first game of the tournament. We were going to have to make some changes that would impact the starting lineup immediately before the first game of the tournament.

Tournament: Group Stage

Our first game in the FIFA U-19 World Championship was against Aus-tralia. In the days leading up to the tournament, I had managed to scout Australia playing Italy in Chiang Mai and had relayed my observations to Phuket immediately after the game.

On November 10 at Rachamangala Stadium in Bangkok, we opened the world championship with a 2–1 victory over Australia. Brit-tany Timko made an immediate impact, scoring both goals in the four-teenth and nineteenth minutes. Importantly, the three points from this victory virtually guaranteed us a spot in the quarterfinals.

Early on, we could see this was going to be a very different tourna-ment from Edmonton 2002. There were few fans in attendance – only around 2,500 people in a 60,000-seat stadium. Towards the end of the game, while sitting on the team bench at field level, you could hear the maintenance crew sweeping out the stadium to get an early start on the clean-up.

The next day, praise was coming from all levels for the sensational performance by Brittany Timko. Tatjana Haenni, a Swiss member of the FIFA Technical Study Group, summarized Timko's game: "She was the only one on the field who took control and asserted herself on the game. She was always calm and assured, but consistently dangerous. Her two strikes were clinical and calm, and killed off the game."

The second game of the group stage, against Thailand, was played on November 13 in Supachalasai Stadium in Bangkok. Again the atten-dance was low, though the tournament organizers exaggerated the num-ber up to 5,000. Regardless, the team took it to the host country 7–0.

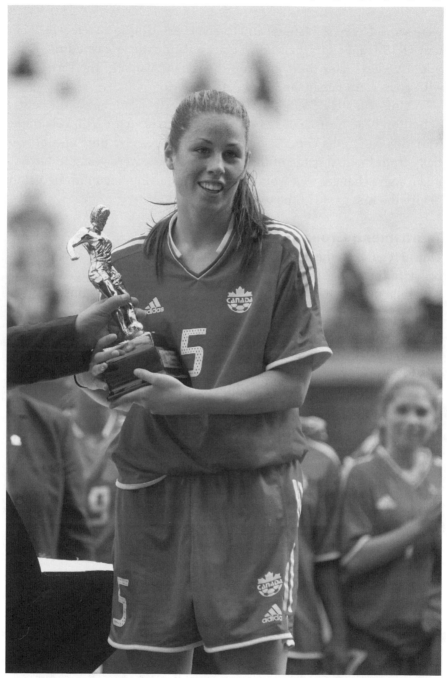

Emily Zurrer emerged as a strong new player, and at the Qualification Tournament was named MVP.

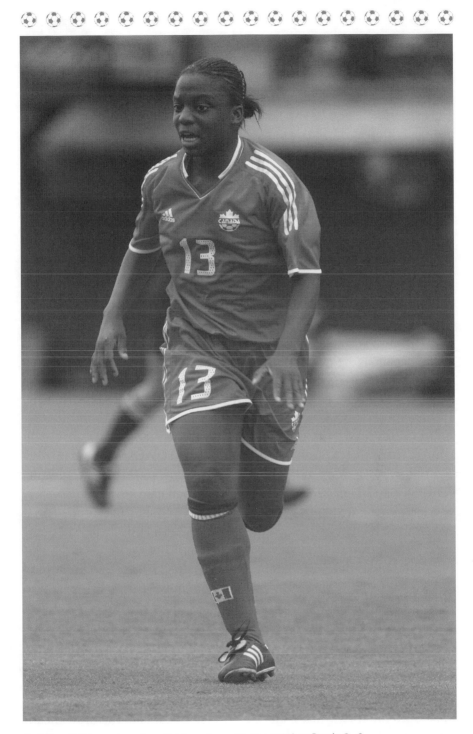

Jodi-Ann Robinson in action. Robinson's goal helped defeat Russia 2–0.

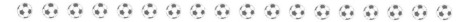

Women's soccer being in its infancy in Thailand, they never threatened our backline or goal and Stacey VanBoxmeer recorded an easy shutout. Single goals were scored by Tanya Dennis, Jodi-Ann Robinson, Véronique Maranda, and Aysha Jamani, while Timko had a hat trick. Even though both teams had two wins to start the tournament, Germany had an edge on us for first place based on goal differential.

"I am very happy with the result because it now guarantees us a quarterfinal berth," said head coach Ian Bridge following the victory. "Our next job is to try and win the group, but that will mean beating a very talented German team, and that is always a difficult task."

The final game of the group stage against Germany was going to produce some challenges we had never faced before. First of all, winning the group is always a confidence booster for any team. But, by winning the group we could potentially end up facing the USA in the semifinal, though we'd have an easier quarterfinal. If we came second to the Germans, we could potentially face Brazil in the semifinal, but have a more challenging quarterfinal. The coaching staff put a lot of energy into forecasting the possible combinations during the time leading up to the game. In the end, we decided not to compromise our ideals by playing for anything less than a victory.

On Tuesday, November 16, in the same stadium we played in against Thailand, we faced the Germans. They started the game by resting three of their strongest players – Celia Okoyino Da Mbabi, Melanie Behringer and Lena Goessling – but still managed to secure an early 3–0 lead in the first thirty-nine minutes. We fought back and scored two goals in the later stages on the first half. Kara Lang struck a booming free kick from thirty-five metres in the fortieth minute, and Véronique Maranda added an awesome strike in the forty-second minute to make the score 3–2. Regardless of the scoreline, this was shaping up to be a very exciting game.

I remember walking past the German coaches at halftime and they were rolling their eyes in astonishment at the outcome of the first-half. The game saw the welcome return of Emily Zurrer to the backline, and the emergence of Sophie Schmidt, who was moved up from the backline to play as a holding or defensive midfielder. Timko tied the game in the sixty-third minute, which is the way the game ended. The draw meant that we would finish second behind the Germans in our pool (equal in

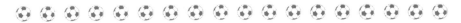

points but behind in goal difference). It was a fantastic feeling to come back from a three-goal deficit, and it gave the team strength and confidence leading into the knockout stage of the tournament.

We were now sitting in the position that we had hoped to achieve prior to the tournament – advancing to the knockout stage. This was now a time to reflect on the success experienced to date: the players were developing in many directions, both on and off the field; and Brittany Timko was emerging as a scoring sensation, leading the tournament with six goals in the first three games.

It was during this time that news of a tragic event in Vancouver had a devastating effect on the team. One of our lifelong soccer friends suffered a heart attack while driving home from a game; Domenic Mobilio was only thirty-five years of age at the time of the death. He had impacted a number of us in so many ways: acting as a coach for some of the girls; as a teammate or opponent for some of the staff; or simply, to many of us, as a longtime friend. He was a dominant force as an attacker and had a prolific career as a striker at many levels of soccer in North America. Following his retirement from the professional ranks, he focused his energy on coaching young soccer players. He will be sadly missed by all of those who were honoured to know him.

Tournament: Knockout Stage

In the days between the end of the group stage and the knockout stage, we were able to explore the canals of Bangkok. It was an eye-opening tour that provided us with a new perspective on Thai culture. The players took time to absorb the culture while remaining focused on their goal of winning the World Championship.

Our quarterfinal match was against China. We were to play in the same Bangkok stadium as our last two group stage matches, directly after the Russia vs. Brazil quarterfinal. The team watched as the Brazilians came from behind to tie the game on the last play of the game, sending it into overtime, which they eventually won 4–1. Those lucky Brazilians always seem to find a way to win! In the other quarterfinal games, Germany snuck past Nigeria in penalty shots while the USA defeated Australia as expected.What we could never have anticipated was the opening minutes of our game against China, and two decisions by the Italian referee Anna De Toni. On a Chinese breakaway, Stacey

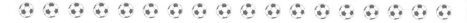

VanBoxmeer came out to challenge for the ball, the Chinese striker went to the ground, and a controversial penalty kick was awarded. To make the situation even worse, VanBoxmeer was shown a red card and we were down to only ten players. Stephanie Labbe became our keeper, immediately allowing a goal – not the way any player wants to enter a game. Ying Zhang scored on the penalty kick, added another goal in the twenty-first minute, and we ended the first half down 2–0.

In the second half, Brittany Timko scored her tournament-leading seventh goal by finishing off a thunderous long-range Kara Lang free kick that the Chinese goalkeeper simply couldn't handle. But shortly after that China responded, and our tournament was over on a 3-1 loss.

It had been just over one year earlier that we had shocked the world when we defeated China at the 2003 FIFA Women's World Cup. The feelings were entirely different this time around, as ecstasy was replaced by silence, sadness, frustration and disappointment.

In the final, Germany defeated China 2–0. Both teams had upset the favoured teams in the semifinals, Germany defeating the Americans and China defeating Brazil. It was a surprise to see the tournament end like this, but again, it reinforced the reality that there is so little you can predict and control.

I have come a long way since our loss to China. It has not been easy, but I have come to realize that the game is not always fair. All we can do is make sure to refocus and take each day with greater understanding of the true meaning behind sport, which rewards us in many ways. The friendships that have grown on this team can and will replace any frustration and disappointment we experienced in Thailand. Additionally, the individual development of players and the teams keeps moving forward. Each new experience at the international level for Canadian women's soccer has provided greater insight and and understanding. In a sense we have learned to value the journey toward the end, rather than focus on the end and forget about the journey.

We have come a long way in a very short period of time. This success has demanded greater respect from the opposition. As well, it insures that we will challenge for gold in each of the 2006 U-20 FIFA Women't Youth World Cup, the 2007 FIFA Women's World Cup and the 2008 Olympics.